National Portrait Gallery

Johan Zoffany
1733–1810

Johan Zoffany, self-portrait (not in exhibition)
Galleria degli Uffizi, Florence

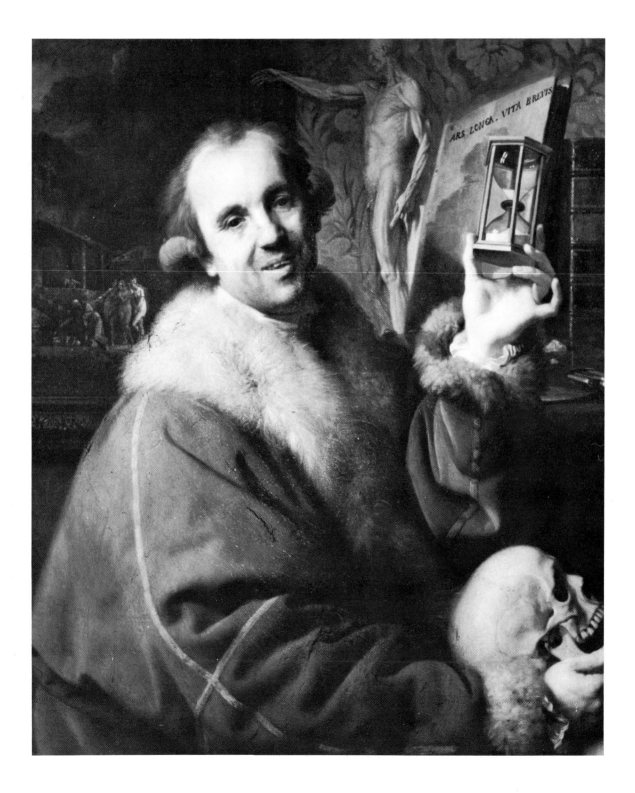

Mary Webster

JOHAN ZOFFANY

1733–1810

National Portrait Gallery

Contents

Front cover
Detail from *Mr and Mrs Garrick by the Shakespeare Temple at Hampton* 1762 (no. 12)
Back cover
Signature from Zoffany's letter of resignation as Director of the Society of Artists (Royal Academy)

Foreword

Zoffany, like Canaletto, is one of those artists who have never lost their appeal. His ability to catch a likeness, his passion for detail, the delightful informality of his conversation pieces and the particular flavour of his sentiment have all contributed to ensure that. Nonetheless, his work has only recently begun to be studied at all seriously; no major exhibition solely devoted to Zoffany has previously been held, though there was a small Arts Council show in 1960–1, which consisted of twenty-three paintings.

The present exhibition is the work of Mary Webster, a specialist in late-eighteenth-century British painting. Miss Webster published her book on Francis Wheatley in 1970, and since that time she has devoted her energies to research on Zoffany. In this exhibition, which she has selected and catalogued with such care and thoroughness, we are exceedingly fortunate in being able to benefit from her recent studies and from the discoveries she has made.

More than half the exhibits have never been seen in public before. The majority of them are portraits, and include a number of Zoffany's studies of actors in part, in which, as Miss Webster points out, gestures and actions are faithfully rendered, providing a splendid record of eighteenth-century acting style. Zoffany's verisimilitude in his interior settings, in the details of costume, and in objects as disparate as musical instruments and cricket bats, is part of the endless fascination offered by his portraits. But we have also been concerned to show Zoffany entire, and have included a number of his early religious and mythological paintings, painted before he left Germany about 1760, and such important later subject pictures as the small panel depicting the maize harvest in Parma and the unusually Hogarthian canvas of *The Plundering of the King's Cellar at Paris*. Unfortunately, few of Zoffany's drawings survive, as most of his sketchbooks and other drawings were destroyed after the death of his widow in 1832.

The setting for the exhibition has been devised with characteristic sensitivity and attention to detail by Joe Pradera; the catalogue has been designed by Roger Huggett. The exacting task of coordinating the whole enterprise has been in the hands of my colleague, Robin Gibson. As always, however, our greatest debt is to those many owners who have so very generously supported the idea of the exhibition from its inception and agreed to lend their pictures. The Trustees wish to express their particular gratitude to Her Majesty The Queen, who has graciously lent no fewer than eleven paintings, amongst them several of Zoffany's masterpieces.

John Hayes

Director
National Portrait Gallery
August 1976

Published for the exhibition held at the
National Portrait Gallery from 14 January to 27 March 1977

Exhibition designed by Joe Pradera

ISBN 0 904017 11 7
Published by the National Portrait Gallery, London WC2H 0HE
Catalogue designed by Roger Huggett/Sinc
Printed by Raithby, Lawrence & Company Ltd, Leicester and London

Acknowledgements

To Dr John Hayes, Director of the National Portrait Gallery, I am greatly indebted for the opportunity of holding this exhibition. It is a pleasure to record my warmest thanks to the staff of the Gallery, and especially to Mr Robin Gibson and Miss Jacquie Meredith whose energy and enthusiasm have contributed so greatly to it. My thanks also go to Mr Richard Ormond and Miss Mary Pettman for the time and care they have devoted to the editorial preparation of the catalogue.

I should like to record here my gratitude to owners of paintings for their kindness and interest in answering my enquiries and for much hospitality. I should like to thank the many institutions and museums which have assisted my work, especially the staffs of the Department of Prints and Drawings of the British Museum, of the Library of the Victoria and Albert Museum and of the Witt Library. I also wish to express my great gratitude to the many kind friends and colleagues who have given me much help and information over the years. My interest in Zoffany was first encouraged by the late Mr Basil Taylor who gave me the benefit of his perceptive knowledge of English eighteenth-century art. The early research was accomplished with the help and support of the Paul Mellon Foundation for British Art. With Sir Oliver Millar, who has most generously shared his wide knowledge, I have had the pleasure of many fruitful discussions. I am deeply grateful to Dr W. G. Archer and Mrs M. Archer for their unfailing interest and assistance, and for many stimulating discussions of Zoffany's Indian period; they have very kindly allowed me to draw on their unrivalled knowledge of Anglo-Indian art and life. My final thanks go to my husband, Ronald Lightbown, who in addition to much help of other kinds has greatly assisted my work.

Mary Webster
August 1976

Introduction

Background and early years The earliest pictures in this exhibition, painted during the 1750s while Zoffany was still trying to establish himself in southern Germany, illustrate the artistic tradition in which he was trained. They represent an aspect of German eighteenth-century art which is unfamiliar in England, that of the small subject picture. By the eighteenth century, German painters were no longer practising an original native style in such paintings. Instead they worked in the genres and manners of the three great artistic traditions of the seventeenth century – those of Flanders, Holland and Italy. The prestige of these seventeenth-century styles in Germany accounts for the preference for a relatively darker key which persists in German painting throughout the eighteenth century and which is so noticeable in Zoffany. It also explains why certain sorts of baroque cabinet picture which had ceased to be popular in other countries remained living genres in Germany – pictures of galleries and collections, of the artist in his studio.

The skilled exactitude with which Dutch and Flemish artists had rendered objects, either in formal still-life compositions or in interior settings, was highly admired and faithfully imitated in eighteenth-century Germany. Other influences were also at work; by 1750 a visit to Italy was obligatory for all aspiring German artists, while many north Italian painters and stucco workers found lavish patrons in German secular and ecclesiastical princes. German artists long continued to paint essays in the classical baroque history genre, usually after the manner of such Venetian painters as Sebastiano Ricci. At Frankfurt and certain princely courts, notably Munich, the general traditionalism was enlivened by the fashionable rococo of France, with its frivolity of theme and lustrous gaiety of colour. These styles did not fuse. Instead artists might work in all of them, adopting for each genre the style traditionally regarded as appropriate: a Netherlandish style for a still-life, an Italian style for a history picture, a French style in portraiture. The artistic milieu in which Zoffany was trained was one of conservatism and eclecticism.

Although Zoffany became an English artist by adoption, and indeed so styled himself to the Emperor Joseph II, explaining that in England he had found protection, he remained faithful to the traditions of his native Germany. He had been brought up at the court of the Prince von Thurn und Taxis, and he received court patronage throughout his career. His most important patrons were princes and princesses of German birth – Charlotte of Mecklenburg-Strelitz, Queen of England, and the family of Hapsburg-Lorraine. In India, two of his most highly placed sitters, Mrs Warren Hastings and Lady Day, were both German in origin. His friends were by no means confined to brother artists, but included a wide circle of men of cultivated tastes, especially in music. At his house at Strand-on-the-Green, which he bought in 1780, he lived in considerable style; his servants wore liveries of scarlet and gold with blue facings, the colours of the arms granted to him by Maria Theresa, and bore on their shoulders the Zoffany crest – a sprig of clover in silver between buffalo's horns, rising out of a baron's coronet. Generous, warm-hearted and impulsive, Zoffany appears at all times to have been fired by a dedicated professionalism, by a need to

study and improve himself, and by a desire to excel. He also had a cultivated painter's knowledge of the history of his art and of the traditions of its styles and genres.

The known events of Zoffany's early life can be told briefly. He was born near Frankfurt on 13 March 1733 and was baptised Johannes Josephus two days later. Zauffaly was the original form of the name, later corrupted in England into Zoffany, and the painter signed his works as Zauffaly until he came to London. His father, Anton Franz Zauffaly (1699–1771), born in Prague, was court cabinet maker and architect to Alexander Ferdinand, Prince von Thurn und Taxis. The family moved to Regensburg when the Prince made it his main residence and here the young Johan, who had shown an early talent for drawing, was apprenticed to Martin Speer (c. 1702–65). Speer was a local painter of some repute who had once been a pupil of Solimena, but too little of his work survives for us to assess its importance in the formation of Zoffany's style.

At the end of his apprenticeship Zoffany made a first journey to Rome in 1750, where he studied under the fashionable portrait painter Masucci. The excellence of his early academic training is reflected in his technical mastery of materials. He is also said to have been a pupil of Mengs, but in reality was only one of the many students whose drawings Mengs generously corrected. It was however from the example of Mengs that he learnt to prefer the smooth and lustrous manner to the broken sparkling style also in vogue in Central Europe. As with so many of his contemporaries, his sojourn in Rome left him with a lasting enthusiasm for the antique and for the great Renaissance painters, but had little shaping influence on his style. After a short spell in Regensburg Zoffany returned again to Rome; he made at least one interesting friendship there, for later Piranesi was to dedicate to him a plate in the *Vasi, Candelabri, Cippi*.

About 1757, after returning to Regensburg, Zoffany was recommended to Clemens August, Prince-Archbishop and Elector of Trier. Clemens August commissioned from him paintings and frescoes to decorate rooms and a chapel in his palace of Ehrenbreitstein at Coblenz and rooms in his new palace at Trier. Unfortunately nothing survives of these works, which must have been in the German rococo style, familiar from the great abbeys and palaces of southern Germany. However, a few drawings (nos. 117, 118, 119, 120) probably give some idea of Zoffany's manner in this type of work. At some date in the late 1750s Zoffany married Antonie Theopista Juliane Eiselein, the daughter of a Hofkammerat (court councillor) of Würzburg, and shortly afterwards made use of her dowry to take himself to England.

England

Zoffany's reasons for coming here, probably in the second half of 1760, are unknown, but it may be surmised that he saw much more chance of winning fame and fortune in wealthy London than at the Electoral court of Trier. He had the usual struggle to establish himself. One difficulty must have been his ignorance of English; throughout his life he seems to have spoken and written German and Italian more readily, and he always kept a strong German accent. At first he was reduced to painting the gay scenes then fashionable as decorations on clock-faces for the clockmaker Stephen Rimbault (no. 26), who introduced him as a drapery painter to Benjamin Wilson (1721–88). From this hack work he was rescued by the actor David Garrick.

Garrick was Zoffany's first major English patron and can be said to have made his reputation. For him Zoffany painted in 1762 four informal scenes of the Garrick household (see nos. 11, 12, 13), which were probably his first essays in the genre of conversation picture with which he is especially

associated. More important, he painted for Garrick the theatrical pictures which made his name with the public at large.

A fascination with the theatre was common to all European rococo art, for in the gay deceits of masquerade and spectacle the age expressed its rejection of the seventeenth century's stiff and ceremonious gloom. In England the theatrical picture was created by Hogarth, *c.* 1728. Later, the immense success of Hogarth's prints probably suggested to Garrick, ever alert to new means of advertisement, the notion of having himself painted in various roles for subsequent engraving.

Early theatrical portraits tended to show one or more actors in costume, often without an actual stage setting, and indeed this sort of theatrical portrait never lost its vogue. Zoffany portrayed actors engaged in the performance of an actual scene from a play. In such theatrical conversations (eg nos. 10, 15, 18, 23, 47) Zoffany first shows his original qualities as an artist: the ability to portray lively figures in vivid interaction, and his deceptive skill in constructing settings so plausible that they produce the illusion of reality. Occasionally he was not able to avoid some discords in his carefully contrived effects. The figures appear forced in their liveliness, as of an actor performing a piece of stage business, and at times the setting does not fuse with them, either from faults of perspective and proportion or from excessive concentration on detail.

Zoffany's theatrical pictures were an immediate success, but it was the patronage of Queen Charlotte that made him a fashionable as well as an admired artist. He may have been recommended to her by George III's favourite Prime Minister, Lord Bute. Both Bute and the King and Queen were anxious to figure as patrons of learning and the arts in the best traditions of enlightened monarchy. For Lord Bute Zoffany had already painted two of his earliest conversation pictures (nos. 20, 21).

The 'family piece', to give the conversation piece its eighteenth-century name, is often wrongly thought of as a peculiarly English genre. In reality it was well established in Zoffany's Germany. There, however, it was the province of comparatively humble artists. In England, by contrast, where portraiture was the only branch of his art which a painter could practise with any hope of fame and profit, the conversation picture was held in far higher esteem, and artists of the stature of Hogarth and Gainsborough worked in it regularly. Indeed, since payment for portraits was calculated on a *pro rata* basis for the number of sitters, artists must have looked on a commission for a 'family piece' as highly desirable. For the Atholl group (no. 31) Zoffany received the huge sum of 180 guineas, representing a charge of 20 guineas a figure.

The conversation piece presented compositional problems to which the artist had to find convincing and attractive solutions. His first difficulty was a physical one; it was not customary for the sitters to sit grouped as they were later to appear in the picture. However, this had its compensating advantages. If it forced the artist to impose an artificial unity on his sitters, it also freed his invention. Although Zoffany often introduced furniture, pictures and features of interiors from the life, his patrons did not expect him to produce a literal rendering, and were prepared to appreciate the fancy the painter had shown in his composition. The licence allowed the artist is perhaps most obvious in Zoffany's landscape settings. Typical eighteenth-century painters' settings in their summary and artificial character, it is only wishful thinking that has identified in some of them representations of actual scenery. The paradox of Zoffany's art is its union of apparently objective presentation with pictorial invention.

Sometimes Zoffany's conversation pieces can be criticised as being at once too natural and too contrived. In many ways this danger was always

inherent in a genre where all the figures had to be given nearly equal prominence and an interesting action. Another consequence of this obligation is that the figures tend to be disposed in a single plane, since three-dimensional composition would have reduced the importance of some of the sitters too greatly. In spite of such cramping limitations Zoffany managed to give the conversation piece more animation than any of his predecessors except Hogarth. His pictures are peopled with sprightly figures whose liveliness of expression and natural action are usually intertwined into a unity of responding gestures, gracefully diversified by individual activities.

Zoffany's conversation pieces owe much of their success in his own life-time and with posterity to the skilful fidelity with which he painted the drapery of his figures and their accessories. Minute exactness in rendering the details of costume was a convention of German eighteenth-century portraiture, and the intricate lace, the ruched ribbons, the gaily embroidered sprigs, the lustrous satins in which the age delighted were in themselves an attractive challenge to the painter's imitative skill. Zoffany's method is objective in that no details are rendered in terms of light, as they so often were in rococo painting – a point that will readily be grasped on comparing a Zoffany with a Chardin. Yet his rendering is redeemed from literalness by the vivacity and richness of his colour.

Zoffany's treatment of the furnishings in his interior settings observes the same faithfulness to local colour, occasionally with the effect of making his pictures seem like clever combinations of isolated elements. True to rococo tradition, he makes no use of a strong contrast of light and shade to impose an overall unity, and accepts the reaction of the rococo against baroque chiaroscuro. Rococo too is the suavity of his pictorial style, which allies smoothness of finish with warmth of tone.

Zoffany was also in vogue as a painter of single portraits. Amongst the earliest are a number of half-lengths which hark back to the seventeenth century in their sombreness. The single half-length did not give Zoffany much scope for lively and animated action, but in accordance with German convention he often introduced one or more objects reflecting the interests or the profession of the sitter (nos. 14, 26). Zoffany's achievement in the single portrait is mainly to be judged on the whole-length, whether small or life-size. He was no innovator. His figures are posed conventionally, and he makes ample use in his more formal portraits of the set properties of the day; sweeping curtain, pillar and balustrade, chair and table, landscapes whose most prominent feature is a large rough-barked tree-trunk of indeterminate species. In one or two portraits, such as that of Mrs Wodhull (no. 64), we see Zoffany, like other contemporaries, borrowing from Reynolds. Yet in the best of his whole-lengths Zoffany's smooth and gleaming draperies and his gift of suggesting an inner sparkle of life in his sitters are as marked as in his group portraits. Indeed his genuine interest in the accessories of costume and setting enlivens elements in his canvases which other artists treated with scant attention.

His life-size portraits are particularly noticeable for their careful modelling and meticulous, smooth finish, in which they contrast with the lively handling of his small-scale pictures. In all types of portraiture his likenesses were highly praised by contemporaries.

Many good versions of theatrical pictures, and a few of portraits and of genre scenes exist. As an example, one very popular composition is exhibited in two versions (nos. 45, 46). Some of the best versions are very faithful and were undoubtedly executed in Zoffany's studio, under his supervision. Unfortunately all too little is known about his studio and his employment of pupils or assistants.

The course of Zoffany's life, but not that of his art, was changed by the commission Queen Charlotte gave him in 1772 to go to Florence to paint for her the Tribuna of the Uffizi (no. 76). While living in Florence Zoffany joined the English colony which was already established in the city. His relations were particularly close with Lord Cowper, a friendship that is reflected in three paintings (nos. 77, 78, 79), including a musical group of the Gore family with Lord Cowper. Zoffany was at his happiest when showing a group making music; the instruments are accurately and lovingly portrayed, with the fingers of the players correctly placed according to the techniques in favour at the time, and the musical notation is meticulously rendered.

Zoffany also found favour at the Grand-Ducal court of Florence. The ruler of Tuscany was the remarkable Pietro Leopoldo, one of the model princes of the Enlightenment (no. 82). The second son of the Empress Maria Theresa, he owed his throne to the territorial exchange which eighteenth-century diplomacy had engineered between his father's ancestral Duchy of Lorraine and the old Medicean Grand Duchy of Tuscany. Pietro Leopoldo was brought up in Vienna until the age of eighteen and his taste in family portraiture remained that of his birthplace. His patronage of Zoffany may also have been stimulated by the fact that Florence was no longer the centre of a living artistic tradition, but had become a cultural museum. Painted to give pleasure to the Empress Maria Theresa, Zoffany's portraits of the Imperial family (nos. 80, 81) have the same intimate charm as his English family portraits, tempered by a typically Hapsburg insistence on hierarchy and ceremony. This mingled regard for family sentiment and formal state is naturally shown most clearly in the set-piece of the Grand-Ducal family against a background of the courtyard of the Pitti Palace (fig. 1).

In 1776 Zoffany was sent with this great 'family piece' in a specially constructed carriage to Vienna, where he completed the picture. At Vienna on 4 December 1776 the title of Baron of the Holy Roman Empire was bestowed on him by the Empress as a mark of her favour. Later, on his return to England, Zoffany offended George III by using this title without

fig. 1 *Pietro Leopoldo, Grand Duke of Tuscany, with his family* (not in exhibition) Kunsthistorisches Museum, Vienna

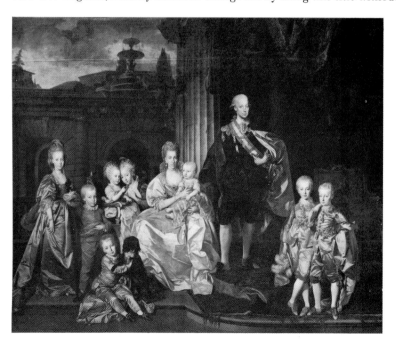

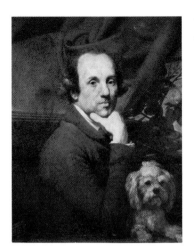

fig. 2 *Johan Zoffany*, self-portrait (not in exhibition) Galleria degli Uffizi, Florence

the King's permission, but in spite of royal disapproval he was occasionally given the title of 'Sir' as an English equivalent.

Returning through Regensburg, where he visited his mother in February 1777, Zoffany went back to Florence to finish the *Tribuna*. He finally left Florence in April 1778, but instead of returning to England at once, halted for a year's stay in Parma. To study Correggio's frescoes and paintings in Parma was the ambition of every eighteenth-century painter, and this was probably one of Zoffany's motives for stopping there. At this time Parma was a Duchy ruled by Ferdinand of Bourbon Parma, whose wife Maria Amalia was a Hapsburg Archduchess. Zoffany found patrons in the princely couple and painted a state portrait of Ferdinand which survives in a number of versions. He also painted the most successful of his Hapsburg family portraits, an enchanting group of the four children of Ferdinand and Maria Amalia (no. 86) which was sent to their grandmother the Empress. Zoffany had a genuine sympathy with children and their games and amusements that gives an attractive sincerity to his pictures of them.

His life in Italy was not free from personal preoccupations and tragedy, and these are reflected in the remarkable self-portraits painted while living in Florence and Parma (fig. 2). The first Mrs Zoffany accompanied her husband to England, but became homesick and returned to Germany. What happened next is difficult to disentangle from the vague hints of contemporaries and memoir writers, but it seems that Zoffany took as his mistress an English Jewess. The second Mrs Zoffany (no. 96), however, was to be a young girl of humble origin whom Zoffany seduced and made pregnant. According to an unverified story she followed him when he left England, and they were married either in Genoa or Florence. Whatever the truth of these assertions it is clear that the second Mrs Zoffany's position was not at first regular in eighteenth-century eyes, although she overcame any original prejudice against her by her modesty, good sense and careful conduct. In Florence she gave birth to a son whose accidental death at the age of sixteen months was a great grief to Zoffany.

The *Self-portrait* (frontispiece) which Zoffany finally gave to the famous collection of artists' self-portraits in the Grand-Ducal Gallery seems to reflect the conflicting drives of these years of Zoffany's life. It is inspired by a sense of mortality and of the transience of time, rare in Zoffany's optimistic century, though less rare perhaps in pious and conservative Germany than elsewhere. Certainly the emblems of a skull and hour-glass which symbolise these feelings are motifs that belong to seventeenth-century portraiture rather than to the 1770s. Above the hour-glass are an *écorché* figure and a book inscribed *Ars Longa Vita Brevis*, signifying that Zoffany felt life to be all too short for the mastery of his art. On the left is a picture of the Temptation of St Anthony, which must refer to the sensual distractions which seek to tempt the painter from the pursuit of painting. The Parma *Self-portrait*, painted on the back of his copy of a *Holy Family* by Correggio, indicates his intention to reform. These *Self-portraits*, confessional and penitential in their mood, and with highly emblematic motifs, could only have been painted by an artist from Central Europe where baroque melancholy and imagery were still a living tradition.

Zoffany responded more deeply to the Italian scene than to either England or Germany. The views of buildings, landscapes and prospects, even the Italian vine he introduces into his backgrounds, are painted with affectionate observation, not cursorily or conventionally. Two pictures survive which are records of Italian life whose picturesqueness had long fascinated northern artists: the *Florentine Fruit Stall* (no. 84) and the *Scartocchiata* (no. 85), a traditional peasant celebration of the maize harvest, held every year in the villages of the Duchy of Parma.

Return to England

Zoffany's years in England from late 1779 to March 1783 were years of disappointment. *The Tribuna*, instead of confirming his reputation, was adversely criticised and lost him the favour of the King and Queen, and his long absence had cost him his vogue as a fashionable portrait painter. Nevertheless, two of his most important pictures were painted during this difficult period. *Charles Towneley's Library in Park Street* showing his famous collection of antique marbles was painted in 1781–3 (no. 95). Zoffany was a friend of the great collector, whom he had known well in Florence, and he painted the picture – another essay in the genre of *The Tribuna* – for his own pleasure. Besides being a key document for English neo-classical taste, this picture, with its cool blues and whites and muted reds, is Zoffany's nearest approach to the neo-classical style in painting. Zoffany's other major work from this period is his celebrated conversation piece of the *Sharp Family* (no. 87). Of this Horace Walpole wrote: '. . . the figures are most natural and highly finished, but a great want of keeping on the whole'. Indeed of all Zoffany's conversation pieces this is the one in which the artificiality of grouping and setting are most conspicuous, but the fact that the picture is so successful shows how wrong it is to approach Zoffany as a purely photographic realist. The brilliant animation of portraiture and colouring are obvious. The background view of Fulham is of unusual precision for an English landscape setting by Zoffany.

India

Zoffany now fell back on the last resource of desperate artists in the eighteenth century and resolved to seek his fortune in Bengal. Lord Macartney, the cultivated Governor of Madras, writing on 23 August 1783 to William Dunkin in Calcutta, introduced 'My friend Baron Zoffani, who is I believe without dispute the greatest Painter that ever visited India', and begged leave 'very seriously to recommend Zoffani to your acquaintance and friendship. You will find him an easy unaffected well informed agreeable Man who will be grateful to you for any Civilities. Your great folks [Mr and Mrs Hastings] I hope will employ him and before their departure, in which case if I am not mistaken they will live as long on Zoffany's canvas as on Mr Auriol's letter paper'. (See nos. 99 and 100.)

On arriving in Calcutta Zoffany found himself in a curious society, made up of younger sons and black sheep from English families, of Scotsmen and Irishmen who had been sent to make their fortunes in the lottery of the East India Company's service; of broken men who hoped to mend their fortunes with Indian gold, of English women many of whom had been sent out on speculation to find husbands, of soldiers, merchants and men of greater or less probity and ability who were the first servants of a nascent colonial administration. It was the Bengal of William Hickey and also of Sir William Jones, in which lavish and ostentatious dissipation existed side by side with the serious and disinterested pursuit of oriental learning. As in all English colonial administrations there were many who lived in as English a style as possible, secluded from all real contact with Indian life. There were others who became partly Indianised, and a few who felt the fascination of the country so greatly that they dedicated their lives to the study of its languages, history, religion, manners and customs. Among the Indians themselves were wealthy princes and merchants who were attracted by European life and arts, most prominent among them the Nawabs of Oudh whose capital was at Lucknow. The central personage of this motley world was undoubtedly the Governor-General, Warren Hastings, an ambiguous figure whose interest in Persian and Sanskrit and oriental learning, and whose cool political skill are beyond all question, but whose actions in maintaining and extending British rule and influence in India were as hotly

debated in his own day as they are now.

For the English of Calcutta Zoffany painted portraits and conversation pieces according to his old formulae, but adding details and figures that suggest the Indian setting. In the majestic state portrait of Mrs Warren Hastings, curtain, pillar, chair, footstool, all the accessories and properties are European, and the sole indication of India is the waving palm trees in the background (fig. 3). Again, in the great conversation piece of the Auriol and Dashwood families (no. 100), his most swagger picture of its kind, only the Indian servants and the jack fruit tree tell us that we are in India and not in the conventional park of an English Zoffany. Such pictures show us the English living to the best of their ability a European life, whose only oriental feature is indulgence in the hookah. India is present in the form of attentive, well-trained, picturesquely dressed servants and a few rather obvious, cursorily painted motifs from Indian landscape.

In other pictures and in his drawings, however, Zoffany has recorded a genuine delight in the exotic scenes of Indian life where all was new and strange: from the robed and turbaned Indians themselves with their brown complexions and flashing eyes to the picturesque landscape with its crumbling shrines and palaces, its steep jungle-crowned river banks, its bathing Hindus, its fakirs squatting under the banyan, its fantastically twisted trees and stately elephants.

It was at Lucknow, at the court of Asaf-ud-daula, Nawab of Oudh, (no. 102), where Europeans and Indians mingled on far more equal terms than in Calcutta, that Zoffany painted his liveliest portrayals of Indian scenes and of the gay amusements of the half-Europeanised Nawab and the half-Indianised Europeans living in his capital. At Lucknow Zoffany also found a friend and patron in the remarkable General Claud Martin (see no. 105), a French military adventurer who had earned great wealth in the service of the East India Company and of the Nawab of Oudh, and who was now in his retirement making a serious study of the antiquities, history and religion of a country he loved. Another proof of Zoffany's own serious interest in India is that he joined the newly founded Asiatic Society, whose researches into all branches of oriental studies were to form one of the most distinguished European contributions to oriental scholarship.

fig. 3 *Mrs Warren Hastings* (not in exhibition) Victoria Memorial Hall, Calcutta

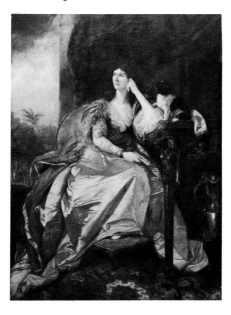

Zoffany's last major picture for Calcutta reflects, however, the growing sedateness of English society in Bengal. This was the altar-piece which he offered to paint for the new church of St John, the first permanent Anglican church to be built in the city. In conformity with the high Anglican tradition, the subject represented was *The Last Supper* (fig. 4). The composition is conventional, and in style Zoffany has reverted to the historical baroque of his early days in Germany. His gift of the altar-piece was intended as a mark of his gratitude for the kindness and patronage he had received in Bengal. A year later, in January 1789, he left for England, in bad health but with his fortune made.

fig. 4 *The Last Supper* (not in exhibition) St John's Church, Calcutta

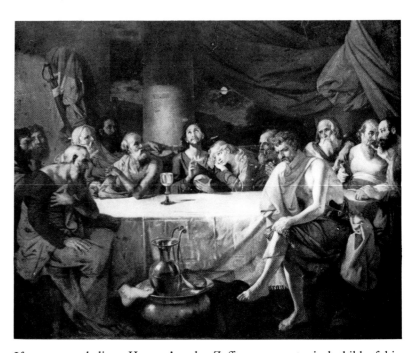

Last years

If we are to believe Henry Angelo, Zoffany was a typical child of his century in the laxness, to say the least, of his religious views, though Angelo was mistaken in thinking that he was a Jew. But, like others of his generation, he stiffened into a pious conservatism as the French Revolution degenerated into violence. In his remarkable picture of *10 August 1792* (no. 108) the savage grotesqueness of the figures expresses his horror of democratic cruelty.

Zoffany also painted two altar-pieces for local churches. In these it must be admitted that he allowed himself a certain degree of sly fun as well as the expression of religious fervour. The altar-piece he painted for Kew was alleged to contain a portrait of a local worthy in the character of Judas Iscariot – a similar story was already in circulation about his Calcutta altar-piece – and was rejected by the indignant authorities, whereupon it was presented to St George's Church, Brentford. Even odder must have been the altar-piece painted for Chiswick Parish Church, which represented *King David Playing the Harp* and a boy pointing to the Seventh Commandment – Thou shalt not commit adultery. This was too much for the Edwardian parishioners of Chiswick who disposed of this picture and its warning at Christie's in 1904 for £2 5s 0d.

After 1800 Zoffany seems to have ceased painting. He died at his house at Strand-on-the-Green on 11 November 1810 and is buried in Kew Churchyard.

Chronology of the known events of Zoffany's Life

1733	13 March	Born near Frankfurt.
	15 March	Baptised in St Bartholomew's, the Cathedral of Frankfurt. (Frankfurt, Bischoflisches Kommissariat, *Abschrift aus dem Taufbuch der Domgemeinde für die Jahre 1717–1753*, p. 111, no. 309.) The confusion over the year of Zoffany's birth arose on account of the adoption of the Gregorian calendar in England only in 1752, after which the beginning of the legal year was changed from 25 March to 1 January; in the Catholic states of Germany it had been in use since 1583.
1750		First visit to Rome.
1753		Earliest dated painting, *The Martyrdom of St Bartholomew*, Alte Kapelle, Regensburg.
1759	29 August	At the court of Ehrenbreitstein.
1760	3 March	Payment for decorations at Trier.
	autumn?	Arrived in England.
1761	5 November	Payment for portrait of Richard Neville Neville (no. 7).
1762		First exhibited at the Society of Artists.
	August	At Garrick's villa at Hampton.
1763	January	Living in the Great Piazza, Covent Garden.
1765		Living in Portugal Row, Lincoln's Inn Fields.
	9 July	Visited by Leopold Mozart.
	December	Opened account at Drummond's Bank.
1769	22 November	Resigned as Director of the Society of Artists.
	December?	Nominated member of the Royal Academy by George III.
1770		First exhibited at the Royal Academy.
1772	3 April	Denization granted.
	May	With Banks and Solander, withdrew from Cook's second expedition to the South Seas.
	9–13 July	In Paris.
	August	Arrived in Florence.
1773	19 August	Elected Academician of Reale Accademia delle Belle Arti, Florence.
1774	10 October	Elected Honorary Academician of the Accademia Clementina, Bologna.
1776	September	Sent to Vienna to finish group portrait of the Grand-Ducal family. (fig. 1)
	4 December	Created a Baron of the Holy Roman Empire by Maria Theresa.
1777/8		Elected Member of the Accademia Etrusca, Cortona.
1778	30 March	Presented his *Self-portrait* (frontispiece) to the Grand Duke Pietro Leopoldo.
	8 June	Elected Honorary Academician of the Accademia di Belle Arti, Parma.

1779	12 November	Walpole went to see *The Tribuna* (no. 76) at Zoffany's house in Albemarle Street.
1783	22 January	Granted permission by the East India Company to go to India.
	8 March	Enrolled as a midshipman on the *Lord Macartney* at Portsmouth.
	23 July	Reached Madras Roads.
	26 August	Sailed for Calcutta.
	15 September	Arrived in Calcutta.
1784	3 June	Arrived in Lucknow.
1785	21 February	In Calcutta, rendered bill to Warren Hastings for nine pictures at 25,050 sicca rupees (£3,026 17s 6d).
	April?	Returned to Lucknow.
1786	November	Left Lucknow for Calcutta.
1787	25 June	*The Last Supper* (fig. 4) for St John's Church, Calcutta, gratefully accepted by the New Church Committee.
	September	In Lucknow.
1788	November	Returned down the Ganges to Calcutta.
1789	23 January	Left Calcutta on the *Granduchessa Maria Luisa*, a French ship carrying Tuscan colours. Changed at St Helena to the *General Coote*, which left 11 May and arrived at Margate 17 August.
1791	October?	In Germany – on the Danube.
1798	2 March	Granted permission by East India Company to return to Bengal 'to settle his private affairs and practise there as a painter'.
1800		Last exhibited at the Royal Academy.
1809	12 March	Farington records, 'Zoffany's faculties were gone. He is become childish'.
1810	11 November	Died.
	17 November	Buried in Kew Churchyard.

Bibliographical note

Zoffany wrote few letters, of which only one entirely in his own hand has been traced (no. 135). It is not known whether he kept an account book or a diary; if so, they would have been destroyed with his other papers and the majority of his drawings, all of which are said to have been burnt after his widow and eldest daughter died of cholera in 1832.

Contemporary accounts are sketchy. The following are the most informative and reliable: J. G. Meusel, *Miscellaneen*, Erfurt, XV, 1783, pp. 131–5; *Notes on Zoffany by Joseph Farington* taken between 1795 and 1804 (in four sections, of which IV is erroneous), printed in O. Millar, *Zoffany and his Tribuna*, 1966, pp. 37–9; J. R. Füssli, *Allgemeines Kunstlerlexikon*, Zurich 1816, pp. 6195–7.

As always, W. T. Whitley, *Artists and their friends in England 1700–1799*, 2 vols, 1928, is a mine of information, and J. T. Smith, *Nollekens and his Times*, ed. W. Whitten, 2 vols, 1920, relates facts not recorded elsewhere. Nevertheless we have little information about Zoffany's personality and conscious aims as an artist. Other references to the artist have to be sought in family histories and papers and in letters. He also appears in the pages of diarists and memoir writers with whom he was connected, but a number of these refer to memories of events long after they took place and are likely to be neither more nor less accurate than present day reminiscence or dinner-table gossip. Thus the anecdotes of Henry Angelo (*Reminiscences*, 1828), and Mrs Papendiek (see no. 96) are either highly-coloured or unreliable.

From the 1820s, fiction and falsification began a century's sway over the biography and works of the artist, reaching their culmination in Lady V. Manners and G. C. Williamson, *John Zoffany R.A.*, 1920, a dangerous book which should only be consulted by those in a position to verify its every statement, and which has been almost entirely disregarded in this catalogue. It has unfortunately been used uncritically by subsequent authors, who have accepted its many questionable statements and attributions, and repeated them as fact in pages or chapters devoted to Zoffany in general histories of English painting of the period. Of these the most perceptive is Sacheverell Sitwell, *Conversation Pieces*, 1936. M. Praz, *Conversation Pieces*, 1971, treats the conversation piece throughout Europe; R. Mander and J. Mitchenson, *The Artist and the Theatre*, 1955, highlights the complexities of versions of theatrical pictures; W. Foster, 'British Artists in India', *Walpole Society*, XIX, 1931, incorporates some facts about Zoffany's Indian period. Totally unacceptable are the highly strained iconographical interpretations of certain pictures proposed by R. Paulson, *Emblem and Expression*, 1975.

The excellent detailed study by Oliver Millar, *Zoffany and his Tribuna*, 1966, and the same author's entries on Zoffany's paintings in his catalogue of the *Later Georgian Pictures in the Collection of Her Majesty The Queen*, 1969, are the only publications in which Zoffany's work has been subjected to scholarly scrutiny.

Catalogue notes

The paintings are arranged in chronological order; engravings of pictures not exhibited are inserted at the date (shown in brackets) of the painting they represent. Graphic works are listed together after the paintings.

Both contemporary and the most recent exhibitions have been included in the entries; other exhibitions are noted where they indicate the history of the picture, or when the catalogue contains a helpful entry or bibliography.

Reference is made to detailed literature only. For the general literature see the bibliographical note (p.19).

Measurements are given in centimetres and (in brackets) inches, height before width.

Abbreviations

S.A.: Society of Artists; R.A.: Royal Academy; B.I.: British Institution; C.S.: John Chaloner Smith, *British Mezzotinto Portraits*, 4 vols, 1884; Whitley: W. T. Whitley, *Artists and their friends in England 1700–1799*, 2 vols, 1928; Manners & Williamson: V. Manners and G. C. Williamson, *John Zoffany R.A.*, 1920.

Germany c. 1745–?1760

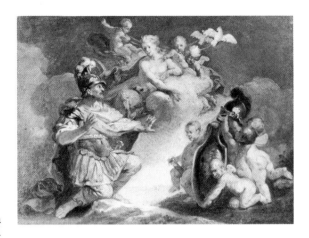

1 The Three Graces *c.* 1750

Panel, 25 × 19.5 (9⅞ × 7¾)
Inscribed on reverse in a later hand: *Zofani f.*

An essay on a favourite theme of academic art in Europe. Probably a very early work; the manner and treatment are characteristically German.

Museum der Stadt Regensburg

2 The Holy Family 1757

Canvas, 53 × 39 (20⅞ × 15⅜)
Signed and dated on step to left of St Joseph: *J. Zauffalij/1757/inv:* Inscribed on scroll held by the putti: *Gloria [in excel] sis D[e]o*

Literature: L. Wickenmayer, *Beschreibung der Gemälde- und Münzen-Sammlung*, Würzburg, 1849, p. 38; *Deutsches Bayerland*, XLIX, 1938, p. 533.

This picture shows the strong influence of Mengs (Dr S. Röttgen compares it with Mengs' *Nativity* in the Accademia di San Luca, Rome). The chiaroscuro composition derives from the much admired *La Notte* of Correggio (Dresden). The subject appears to be St Joseph exhibiting the new-born Christ to other members of the Holy Family.

Mainfränkisches Museum, Würzburg

3 The Sacrifice of Iphigenia 1758

Canvas, 74 × 110.5 (29 × 43½)
Signed and dated lower left: *Zauff[al]i inv./1758*

Provenance: Prof Dr Engelmann, Vienna, from whom purchased 1962.
Exhibition: Bregenz and Vienna, *Angelika Kauffmann und ihre Zeitgenossen*, 1968 (490).

An essay in the German version of the Venetian classical baroque. The picture has been called the Sacrifice of Polyxena, but clearly represents Iphigenia being sacrificed by the priest Calchas. On the right is her father Agamemnon, looking heavenwards for the wind which the gods have promised for the becalmed Greek fleet, shown on the left, in return for the sacrifice of his daughter.

Mittelrhein Museum, Coblenz

4 Venus bringing arms to Aeneas 1759

Canvas, 27.6 × 38 (10⅞ × 14⅞)
Signed and dated lower right: *Zauffaly inv/1759*

Provenance: purchased 1966.

A study probably for a decorative composition, since the heroic classical baroque style is modulated into smiling rococo prettiness. The subject, Venus bringing arms forged by Vulcan to aid her son Aeneas in his war against the Latins (Virgil, *Aeneid*, VIII, 608 ff.), was very popular with late baroque artists.

City of Manchester Art Galleries

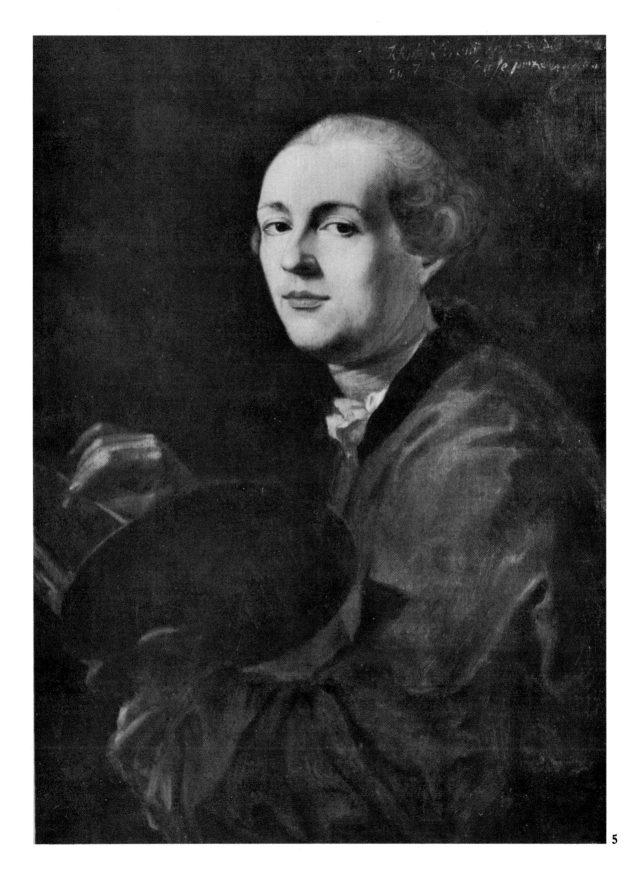

5

5 Self-portrait *c.* 1759

Canvas, 87×60.5 (34¼×23⅞)
Inscribed in an early-nineteenth-century hand:
Joseph Zofanii . . . se ipse pinx

Literature: C. Heffner, *Die Sammlungen des historischen Vereins für Unterfranken und Aschaffenburg zu Würzburg*, Würzburg, 1875, p. 33.

This unfinished picture, painted in a courtly rococo style, is Zoffany's first known essay in the self-portrait, a genre dear to German artists of the eighteenth century. It was probably painted during the time of his appointment as court painter to the Elector of Trier.

Mainfränkisches Museum, Würzburg

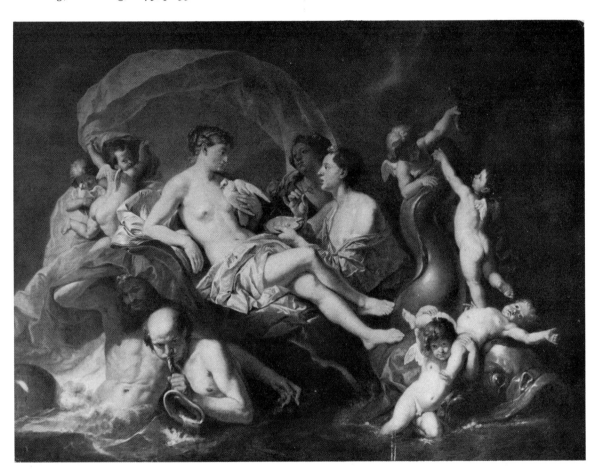

6 Venus Marina 1760

Canvas, 125×172 (49¼×67¾)
Signed and dated on the shell above the Triton's hand:
Zauffaly inv.1760

Provenance: given by M. Doucet, 1805.
Exhibitions: Bordeaux, 1952–3 (57); Paris, Galerie Cailleux, 1969 (49), with previous literature.

The composition is one of the many derivations of the much imitated *Galatea* of Raphael. Here the subject is the Marine Venus holding her attribute, the dove, while a sea nymph offers her a branch of coral and pearls in an oyster shell. Below the shell which is her car are two Tritons. Cupids, one holding a dove, shade her with a pink drapery, while other Cupids gambol with the dolphin which draws her car.

This accomplished picture is a rococo treatment of a popular Renaissance theme. In the greater realism with which certain elements, notably the faces, are treated and its relatively darker key, it is typical of the German version of the international rococo style. A companion picture, *Venus and Adonis*, is also at Bordeaux.

Musée des Beaux-Arts de Bordeaux

England ?1760–1772

7 Richard Neville Neville 1761

Canvas, 76.1 × 63.5 (30 × 25)

Provenance: by descent.
Engravings: line engraving by J. Basire as plate to Coxe's *Life of Stillingfleet*, 1810; P. W. Tomkins as plate to Lord Braybrooke's *History of Audley End*, 1836, p. 105
Exhibition: Cambridge, Heffers, 1961.
Literature: R. J. B. Walker, *Audley End, Catalogue of the Pictures in the State Rooms*, 1973, p. 50.

Richard Neville-Aldworth (1717–92) succeeded in 1762 to the Billingbear estate after the death of the Countess of Portsmouth, when he took the surname and arms of Neville. He married Magdalen (d. 1750), daughter of Francis Calandrini, First Syndic of the Republic of Geneva. His son Richard succeeded as 2nd Lord Braybrooke.

MP for Wallingford 1747–74, Neville became an Under Secretary of State in 1748, Secretary to the Embassy at the Court of France in 1762 and Minister Plenipotentiary there in 1763.

Painted in the autumn of 1761, this accomplished portrait was one of Zoffany's earliest commissioned works after his arrival in England. (Neville Account Book, 5 November 1761: 'Zoffany for my picture £6'. Essex Record Office D/D By.A 380.)

The Hon Robin Neville

8 Sir Richard Neave *c.* 1761

Canvas, 78.7 × 59.7 (31 × 23½)
Signed: *Zoffanij Pinxt.*
Inscribed in a later hand: *SIR RICHD NEAVE BART,/1751 ÆTATIS. 21*

Provenance: by descent.
Exhibitions: Cardiff, National Museum of Wales, 1951 (66); Arts Council, *Johann Zoffany*, 1960 (1).
Literature: J. Steegman, *A Survey of Portraits in Welsh Houses*, I, 1957, p. 8.

Sir Richard Neave, 1st Bart (1731–1814), of Dagnam Park, Essex. Neave was appointed a Governor of the Bank of England in 1780 and created a baronet in 1795. In February 1761 he married Frances, daughter of John Bristow of Quiddenham Hall, Norfolk.

This half-length portrait within a painted oval of Richard Neave wearing Van Dyck costume was probably commissioned about the time of the sitter's marriage. The arms at the left are those of Neave and his wife. The inscription on the right which can only have been added after Neave was created a baronet in 1795 has led to the picture being wrongly dated in the early 1750s. A date before Zoffany's arrival in England is unacceptable on grounds of style, and can be ruled out by the form of the signature which in the 1750s would have been Zauffaly.

Sir Arundell Neave, Bt

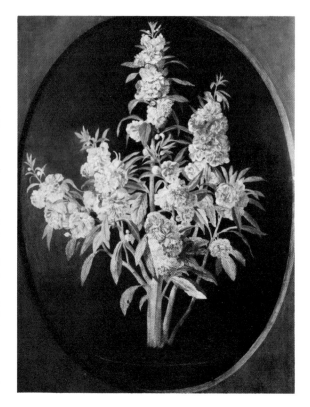

9 A Balsam *c.* 1761

Canvas, 91.8 × 71.1 (36⅛ × 28)

Provenance: first recorded in the Private Closet at Kensington in 1818 (561: A Balsam. Zoffani. Measurements given as 36 × 32 in).
Literature: O. Millar, *Later Georgian Pictures in the Collection of Her Majesty The Queen*, 1969, no. 1212.

An accurate portrait in a painted oval of the cultivated double-flowered form of the common Balsam (*Impatiens balsamina*), which had been very popular as a pot-plant since the sixteenth century.

The meticulous attention to the details of still-life and flowers which Zoffany shows in many of his later portraits recalls his early interest in these two branches of painting. In the absence of any other flower-piece by Zoffany, though he is known to have painted at least three (sale Langford 23 February 1763 (7,23)), no direct stylistic comparison is possible, but the early ascription of this *Balsam* to Zoffany should be considered as a sure argument. Probably painted soon after his arrival in England, before he had established himself as a portrait painter. The grey-green tonality is typical of his work of 1761–3; the treatment of the foliage may be compared with the string of onions hanging on the wall in *Garrick in 'The Farmer's Return'* (no. 10).

Her Majesty Queen Elizabeth II

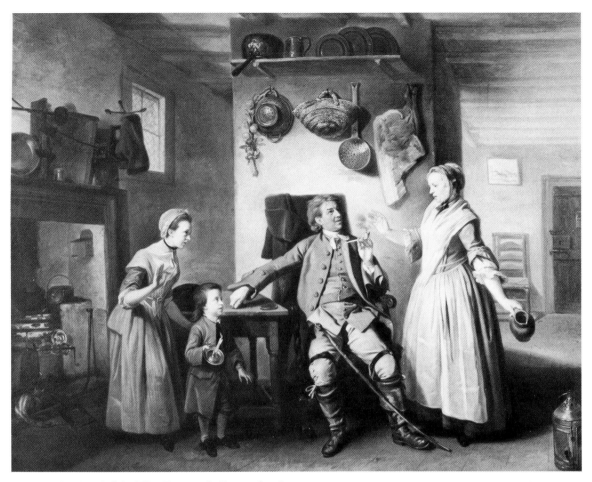

10 David Garrick in 'The Farmer's Return' 1762

Canvas, 101.6 × 127 (40 × 50)

Provenance: painted for Garrick, sale Christie's 23 June 1823 (43); bt. Seguier for the Earl of Durham, by descent.
Engraving: mezzotint by J. G. Haid, 1766.
Exhibitions: S.A., 1762 (138); Arts Council, *The Georgian Playhouse*, 1975 (21).

The Farmer's Return, an interlude written by Garrick for the benefit of Mrs Pritchard, was first produced at Drury Lane on 20 March 1762 with Garrick as the Farmer and Mrs Mary Bradshaw as the Farmer's wife. The Farmer had been to see the coronation of George III on 22 September 1761 and is relating to his incredulous family his supposed adventure with the Cock Lane ghost, a nine days wonder of 1762, eventually exposed as a hoax.

Painted between the first performance and the end of April 1762, when the Society of Artists exhibition opened, this picture, Zoffany's first important commission, established his reputation. A contemporary newspaper critic described it as 'a most accurate representation on canvas of that scene as performed at Drury Lane. The painter absolutely transports us in imagination back again to the theatre. We see our favourite Garrick in the act of saying, *for yes, she knocked* once – *and for* no *she knocked* twice. And we see the wife and children – and we saw them on the stage – in terror and amazement; such strong likenesses has the painter exhibited of the several performers that played the characters'. Walpole approved of this work by a newcomer to the exhibition: 'Good, like the actors, and the whole better than Hogarth's'. (Whitley, I, p. 180).

Zoffany has produced a Dutch genre picture with still-life objects hanging on the wall, an evening light coming in through the window. A typical, if involuntary, touch is the fault in perspective which gives the ceiling the appearance of sloping to the right.

With no. 15 this picture hung in Garrick's dining parlour in his house at the Adelphi.

Lord Lambton

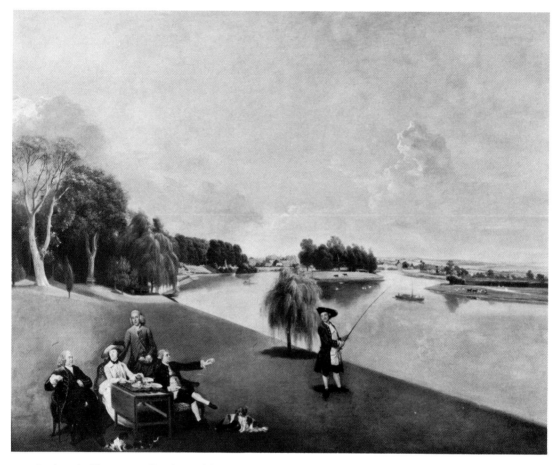

11 A view in Hampton Garden with Mr and Mrs Garrick taking tea 1762

Canvas, 99.7 × 125 (39¼ × 49¼)

Provenance: painted for Garrick, sale Christie's 23 June 1823 (53); bt. Seguier for the Earl of Durham, by descent.

Exhibitions: Conversation Pieces, 1930 (151); R.A., *British Art*, 1934 (248); Arts Council, *British Sporting Painting*, 1974 (65); Arts Council, *The Georgian Playhouse*, 1975 (82).

David Garrick (1717–79), the celebrated actor, is seated to the right of the table. He holds out a cup to his brother George (1723–79), assistant at Drury Lane, who is fishing in the Thames; Mrs Garrick (1724–1822) pours out the tea. Waiting beside her stands the butler Charles Hart, who was a trusted servant of Garrick. The man seated at the left, formerly thought to be Dr Johnson, can now be identified from Garrick's inventory (Victoria and Albert Museum, *Descriptive Inventory of the Household Furniture and Fixtures belonging to . . . the late David Garrick, Esq. . . 18 February* 1779) as George Bodens, who was awarded high marks as a social companion by Mrs Thrale. 'Colonel Bodens is a Man of much wit, Archness and a peculiar Vein of humour – his sayings are circulated about the Town with which he is a singular favourite. I have often thought his odd Person and Appearance contributed something towards forwarding his Reception: The enormous Weight of flesh, the stammering and sore leg are all to his Advantage as he contrives them; and people . . . seem resolved to find humour in everything he does or suffers.' (*Thraliana*, ed. K.C. Balderston, I, 1942, pp. 4, 330.)

This conversation group, its companion (no. 12) and two smaller views of Hampton House and garden with figures (no. 13) are Zoffany's first essays in the genre. The preponderance of landscape over figures, the wide sky and light key, reflect the influence of contemporary Venetian painters, especially Canaletto, who had been in England painting views, peopled in the foreground, during the 1750s.

Executed in the summer of 1762, after Zoffany had broken his engagement as drapery painter to Benjamin Wilson. Zoffany was protected by Garrick who bought out the remainder of his time (Farington Diary 6 December 1804), and wrote firmly to Wilson: 'I shall do his [your] German friend all ye good offices in my Power; he was warmly recommended to me by my Acquaintance, is a man of Merit and well behaved in my family'. (*The Letters of David Garrick*, ed. D. M. Little and G. M. Kahrl, I, 1963, p. 363.)

Lord Lambton

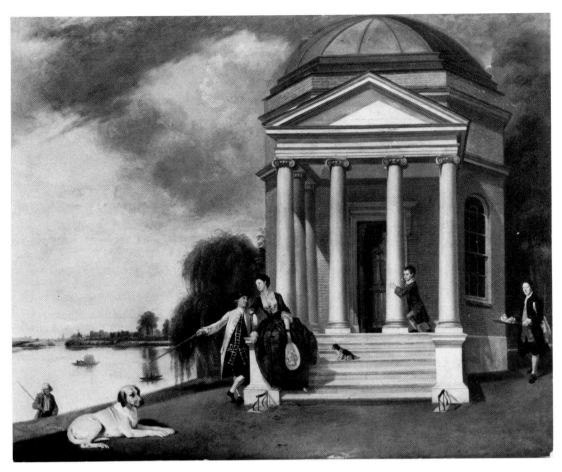

12 Mr and Mrs Garrick by the Shakespeare Temple at Hampton 1762

Canvas, 99.7 × 125 (39¼ × 49¼)

Provenance: painted for Garrick, sale Christie's 23 June 1823 (54); bt. Seguier for the Earl of Durham, by descent.
Exhibitions: Conversation Pieces, 1930 (107); Arts Council, *The Georgian Playhouse,* 1975 (83).

See no. 11, with which this picture hung in the dining parlour of Garrick's town house at the Adelphi. Mrs Garrick is sitting on the balustrade of the Shakespeare Temple, resting her arm on the shoulder of her husband who points to their waterman coming up the bank from the Thames. The child playing by the column is one of Garrick's nephews, probably Carrington Garrick (1753–87), his brother George's eldest son; a servant brings tea.

In 1749 Garrick married Eva Maria Veigel, a Viennese dancer who came to London with the Italian opera company in 1746 and made a triumphant début as a ballet dancer, under the stage name of Violette, at the Opera House in the Haymarket. She remained in England under the patronage of the Earl and Countess of Burlington until her marriage.

The pretty house at Hampton that Garrick bought in 1754 owed much of its interior elegance to Mrs Garrick's good taste. A new front was added to the house by Adam who also designed the octagonal Shakespeare Temple for the garden in 1755. Roubiliac's statue of Shakespeare (now in the British Museum), seen through the portico, was put in place in 1758. The garden was landscaped and planted by Capability Brown; the small willows in this picture and no. 13, which also shows two young conifers, had grown considerably by the time of Farington's view, drawn about 1790. (*The Letters of David Garrick,* ed. D. M. Little and G. M. Kahrl, I, 1963, opp. p. 212.)

Lord Lambton

13 A view of Hampton House and Garden with Garrick writing 1762

Canvas, 61×73.6 (24×29)

Provenance: painted for Garrick, sale 23 June 1823 (52); bt. Smart.
Literature: C. H. Collins Baker, *Catalogue of the Petworth Collection*, 1920, no. 107 (as W. Hodges).

Garrick is sitting writing on the lawn of his villa at Hampton; on the right a horse pulls a heavy lawn-roller. This picture, which hung in the dining parlour of Garrick's town house at the Adelphi, as an overdoor, shows a view of the side of Hampton House with the newly landscaped and planted gardens. Stylistically similar to the two conversation groups of the Garricks at Hampton, nos. 11 and 12, this delightful landscape was undoubtedly painted during Zoffany's stay with the Garricks in the summer of 1762.

The Lord Egremont

14 Benjamin Stillingfleet (*c.* 1762)

Mezzotint by Valentine Green, 1782
35.5×25.5 (14×10)

Literature: C. S., p. 587, no. 124.

Benjamin Stillingfleet (1702–71) author and naturalist, was a friend of Richard Neville Neville (no. 7) and Robert Price of Foxley. He is portrayed holding a magnifying glass and a volume lettered *Linnaeus Species Planta Tom.*1. The grasses on the table allude to the publication of his 'Observations on Grasses', with plates drawn by Robert Price, which appeared in his *Miscellaneous Tracts*, 1762.

National Portrait Gallery, London

15 David Garrick and Mrs Cibber in 'Venice Preserv'd' *c.* 1762–3

Canvas, 101.6×127 (40×50)

Provenance: painted for Garrick, sale Christie's 23 June 1823 (42); bt. Seguier for the Earl of Durham, by descent.
Engraving: mezzotint by J. MacArdell, 1764.
Exhibitions: S.A., 1763 (137); Arts Council, *The Georgian Playhouse*, 1975 (22).

The part of Jaffier in Thomas Otway's tragedy *Venice Preserv'd* was played by Garrick between 1748 and the season of 1762–3, when with Mrs Cibber as Belvidera three performances were given.

Zoffany has depicted the scene in Act IV, Scene ii, which leads up to the final tragedy and death of all three principals:

Jaffier: Know, Belvidera, when we parted last I gave this dagger with thee, as in trust to be thy portion, if I ever proved false. On such condition, was my truth believed; But now tis forfeited, and must be paid for. (offers to stab her again)
Belvidera: Oh! Mercy (kneels)
Jaffier: Nay, no struggling

The enthusiastic reception of *The Farmer's Return* (no. 10) undoubtedly encouraged Garrick in his patronage of Zoffany, and led to this second commission for a theatrical conversation, shortly after the performance on 20 October 1762. The two pictures hung together on the wall opposite the fireplace in Garrick's dining parlour in his house at the Adelphi.

James Boswell records with amusement on 13 January 1763 that Garrick 'then carried me to see the paintings of Mr. Zoffany in the Piazzas, where Mr. Garrick is shown in several different ways. 'Take care, Zoffany' said he, 'you have made one of those heads for me *longer* than the other, and I would not willingly have it shortened'. (*Boswell's London Journal 1762–3*, ed. F. A. Pottle, 1950, p. 141.)

Lord Lambton

16 Simon Francis Ravenet (c. 1762–3)

Line engraving by S. F. Ravenet, 1763
18.5 × 12.5 ($7\frac{1}{4}$ × $4\frac{7}{8}$)

Simon Francis Ravenet (?1721–74), engraver, was a friend of Zoffany's. A pupil of Jacques Philippe Le Bas, he came to London in 1750, where he was employed by Alderman Boydell and by the booksellers. He made designs for the Chelsea china factory.

Victoria and Albert Museum

17 John, 4th Earl of Sandwich (1763)

Mezzotint by Valentine Green, 1774
50.8 × 35.5 (20 × 14)

Literature: C.S., p. 584, no. 117.

John, 4th Earl of Sandwich (1718–92), holds a letter addressed to the Earl of Sandwich, First Lord Commissioner of the Admiralty. Among several state offices, he was appointed First Lord of the Admiralty 1748–51, 1763 and 1771–80, and in the latter period particularly he used the patronage of office for bribery and political jobbery. The painting from which this mezzotint was scraped was formerly at Trinity House (destroyed); it was probably painted at the time of Sandwich's appointment as First Lord of the Admiralty in 1763.

Victoria and Albert Museum

18 David Garrick in 'The Provok'd Wife' 1763–5

Canvas, 99.1 × 124.5 (39 × 49)

Provenance: painted for Garrick, by descent to Mrs Trevor, sale Sotheby 19 July 1972 (28); purchased for Wolverhampton through the NA-CF 1976.
Engraving: mezzotint by J. Finlayson, 1768.
Exhibitions: S.A., 1765 (167); Arts Council, *The Georgian Playhouse*, 1975 (27).

The part of Sir John Brute in Vanbrugh's comedy *The Provok'd Wife* was played by Garrick throughout his career. With the cast here depicted it was performed on 18 April 1763; the watchmen are played by Henry Vaughan, Hullet, Thomas Clough, William Parsons, Thomas Phillips and Watkins.

Zoffany has painted the scene in Garrick's rewritten version, in which Sir John Brute in a drunken frolic with Lord Rake and Colonel Bully has robbed a journeyman tailor of a suit of clothes intended for his own wife, and is about to be arrested by the Watch: Sir John: Sirrah, I am Boudoucca, Queen of the Welchmen, and with a leek as long as my pedigree, I will destroy your Roman legion in an instant – Britons, strike home. (Act IV Scene i).

A study for the central figure of Garrick, in which the head is said to have been altered at the sitter's request (Shakespeare Memorial National Theatre Trust), must have been painted before Garrick's departure for the Continent (September 1763 – April 1765). The present picture hung in Garrick's dining parlour at Hampton.

Wolverhampton Art Gallery

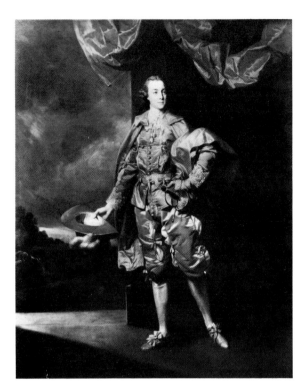

19 John, Lord Mountstuart, in masquerade dress *c.* 1763–4

Canvas, 91.5 × 71 (36 × 28)

Provenance: by descent.
Exhibitions: R.A., *European Masters of the Eighteenth Century,* 1954–5 (118).
Literature: J. L. Nevinson, 'Vandyke Dress', *The Connoisseur,* CLVII, 1964, pp. 166–71, pl. 8.

John, later 1st Marquess of Bute (June 1744–1814), eldest son of the 3rd Earl of Bute and his wife Mary (only daughter of Edward Wortley Montagu), as Lord Mountstuart. The sitter is wearing a deep yellow Van Dyck masquerade costume, pulled in at the waist by a sword-belt from which hangs an Italian seventeenth-century cup-hilt rapier; he holds a wide-brimmed and plumed Cavalier hat.

In portraying his sitter before a pier in front of which hangs a full baroque curtain, with a stormy landscape stretching away in the background, Zoffany has caught the spirit of the historic and the romantic expressed by Van Dyck costume. Its popularity with the fashionable public as a masquerade dress, which began in the 1740s and lasted for over forty years, grew with the cult of the picturesque and was at its height in the 1760s and early 1770s.

Probably painted at about the same time as the two conversation groups of the sitter's younger brothers and sisters (nos. 20 and 21).

The Viscount Sandon

20 Three sons of John, 3rd Earl of Bute *c.* 1763–4

Canvas, 100.5 × 122 (40 × 48)

Exhibition: Conversation Pieces, 1930 (4).

The sitters are the three younger sons of the 3rd Earl of Bute, close friend of George III and Prime Minister 1762–3, and his wife Mary. On the left stands the Hon Frederick Stuart (September 1751–1802) holding up his hat ready to receive the bird and nest full of eggs handed to him from the tree by his youngest brother, the Hon William Stuart (March 1755–1822), later Archbishop of Armagh. These proceedings are watched by a hopeful white poodle. On the right, holding a bow and indicating the bull's-eye he has just scored, is the Hon Charles Stuart (January 1753–1801), later Lieutenant-General, who captured Minorca from the Spaniards in 1798.

This group and its companion (no. 21) are amongst the earliest of Zoffany's portraits with small whole-length figures grouped together in a lively interaction. They mark the artist's development from a composition in which the landscape and architectural features dominate the very small figures – such as the three pictures painted for Garrick in the latter part of 1762 (nos. 11–13) – to one in which the grouping and actions of the sitters are combined with accurate and telling likenesses.

It is probable that Lord Bute introduced Zoffany to George III and Queen Charlotte shortly after this group and no. 21 were painted, but no evidence has so far come to light. (I am indebted to Miss C. Armet for her kind assistance in searching for documents connected with Lord Bute's commissions to Zoffany.)

Private collection

21 Three daughters of John, 3rd Earl of Bute *c.* 1763–4

Canvas, 100.5 × 122 (40 × 48)

Exhibition: Conversation Pieces, 1930 (8).

See no. 20. Playing with two pet squirrels are three of the younger daughters of the 3rd Earl of Bute. At the left is Lady Louisa Stuart, the youngest member of the family (August 1757–1851), whose entertaining letters and biographical memoirs reflect a literary inheritance from her grandmother, Lady Mary Wortley Montagu. She holds a hazel-nut and is trying to tempt back a squirrel which has escaped. Standing at the right on a wooden garden bench, and holding on to the string attached to a second squirrel, is Lady Caroline Stuart (May 1750–1813), who later married Lord Portarlington. Between them is seated an older sister, probably Lady Anne Stuart (1746 – after 1779), who married Lord Percy in July 1764. The Palladian gatehouse on the right has not been identified; it may be connected with Old Luton, bought by the 3rd Earl in 1763. A date for this group and its companion, no.

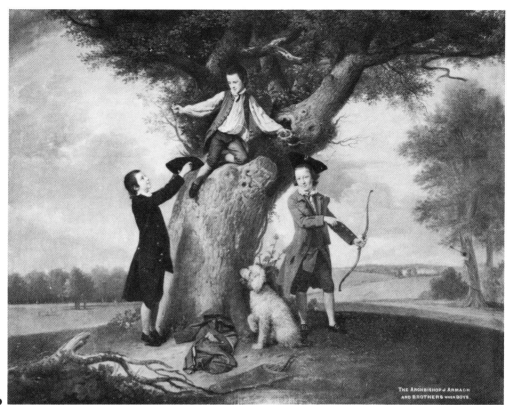

20

THE ARCHBISHOP of ARMAGH
AND BROTHERS when BOYS.

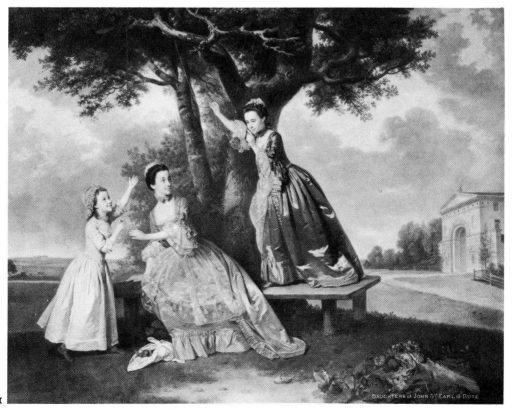

21

DAUGHTERS of JOHN 3rd EARL of BUTE.

20, of 1763–before July 1764, when Lady Anne married, is probable on stylistic grounds and agrees with the ages of the sitters. The grey-green backgrounds are close in tone to those of the Garrick views at Hampton (nos. 11-13).

Private collection

22 John Moody in 'The Beaux Stratagem' *c.* 1763-4

Canvas, 88.2×60.3 (34¾×23¾)

Provenance: Lord Charlemont; Sir Henry Irving; Sotheby 13 October 1954 (165).
Engraving: mezzotint by J. Marchi.
Exhibitions: S.A., 1764 (145); B.I., 1867 (208).

John Moody (1727?–1812) as the Irish priest, Father Foigard, in Farquhar's *The Beaux Stratagem.* Foigard's stratagem to gain freedom to plot is by concealing that he is an Irishman serving with the French army. The excellent likeness of Moody as Foigard was remarked upon by contemporaries. His humorous manner in this part, which he performed at Drury Lane on 22 September 1763, added greatly to his reputation.

Lord Charlemont's request to his bankers on 29 October 1764 'to pay to Mr Zoffani the sum of Twenty Guineas' is very probably connected with his purchase of this picture. (British Museum Department of Prints and Drawings, Anderdon R.A., I, f.176.)

Arthur Richard Dufty, Esq

23 Samuel Foote in 'The Mayor of Garratt' 1764

Canvas, 101.6×127 (40×50)

Provenance: presumably painted for Foote; George Colman, sale Christie's 3–4 August 1795 (96); bt. Woolmer, sale Christie's 7 May 1796 (106); bt. Bryan for the Earl of Carlisle (kindly communicated by Mr J. Kerslake).
Engraving: mezzotint by J. G. Haid, 1765.
Exhibitions: S.A., 1764 (140); Arts Council, *The Georgian Playhouse,* 1975 (24).

Samuel Foote (1720–77) wrote *The Mayor of Garratt* in 1763. A topical play, it was based on the custom of the villagers of Garratt, near Wandsworth, who chose a mayor to look after their rights whenever a general election took place. Foote in the role of Major Sturgeon of the Westminster Militia and Robert Baddeley (1732–94) as Sir Jacob Jollop open the play:
Sir Jacob Jollop: There has, Major, been here an impudent pillmonger, who has dared to scandalize the whole body of the bench.
Major Sturgeon: Insolent companion! had I been here I would have mittimused the rascal at once.
The Mayor of Garratt, first performed on 20 June 1763, was played with these two actors in the leading parts at Drury Lane as an afterpiece between 30 November and 9 December 1763.

The flowers and objects in the background, added to give a realistic effect, are painted in careful detail, though the perspective of the chimney-piece is slightly out of true.

Foote quickly took advantage of the absence of his rival Garrick, who had left London for a visit to the Continent in September 1763, by commissioning Zoffany to paint for him a picture in the new and popular genre of theatrical conversations. On 25 October an entry in his account at Drummond's Bank reads 'To Cash Paid for Jn. Zoffany £42', a sum that may be connected with a pre-payment for the present picture.

Walpole, who noted it as one of the three best pictures in the exhibition of 1764, found it 'admirably natural'.

Private collection

24

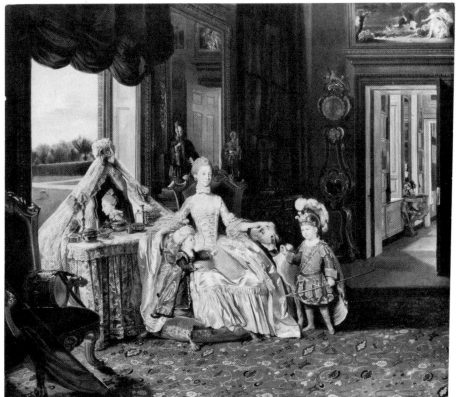

25

24 George, Prince of Wales, and Frederick, later Duke of York 1764

Canvas, 111.8 × 127.9 (44 × 50⅜)

Provenance: perhaps painted for Queen Charlotte.
Exhibition: R.A., *King's Pictures,* 1946–7 (46).
Literature: O. Millar, *The Later Georgian Pictures in the Collection of Her Majesty The Queen,* 1969, no. 1200; J. Fowler and J. Cornforth, *English Decoration in the 18th Century,* 1974, pp. 162–3.

The two eldest sons of George III and Queen Charlotte in the second Drawing-Room or Warm Room at Buckingham House. George, Prince of Wales (August 1762–1830), holding his hat, stands beside his brother Prince Frederick (August 1763–1827), who is seated on a chair that has been drawn into the centre of the room. The children, who both wear infants' 'coats', are playing with a small spaniel.

The informal nature of this portrait of the two young princes is emphasized by the case covers that have been left on the chairs and sofa. Sir Oliver Millar has noted (*op. cit.*) that although certain features of the room – the two group portraits by Van Dyck, the marble chimney-piece and the door-case reflected in the mirror above it – are a faithful rendering of the room as it then was, Zoffany has introduced three other pictures on the wall to the left of the fireplace. The reflection in the mirror is already an artistic transposition, for in reality the window wall would have been seen. The portraits of the King and Queen to the left of the fireplace are almost certainly inventions by Zoffany, that of the Queen being taken from the same sitting as no. 25, while the King was presumably devised, perhaps from a miniature, as a pair to it. Zoffany has imported from another part of the house the *Infant Christ* by a follower of Maratta that hangs above.

Lady Charlotte Finch recorded in her diary that Prince Frederick 'walked quite alone' for the first time on 11 September 1764 (O. Hedley, *Queen Charlotte,* 1975, p. 93), and he is perhaps portrayed here before he walked steadily. Painted in the autumn of 1764 or early 1765 at the same time as no. 25, and certainly before 31 March 1765 when Prince George was breeched.

Her Majesty Queen Elizabeth II

25 Queen Charlotte with her two eldest sons 1764

Canvas, 112.4 × 129.2 (44¼ × 50⅞)

Provenance: perhaps painted for Queen Charlotte.
Exhibitions: R.A., *British Art,* 1934 (236); The Queen's Gallery, *George III Collector and Patron,* 1974–5 (18).
Literature: O. Millar, *The Later Georgian Pictures in the Collection of Her Majesty The Queen,* 1969, no. 1199; O. Hedley, *Queen Charlotte,* 1975, pp. 83–4, 93; K. M. Walton, 'Queen Charlotte's Dressing Table', *Furniture History,* XI, 1975, pp. 112–13.

This famous conversation piece of Queen Charlotte and her two eldest sons in fancy dress is one of Zoffany's most elaborately contrived and perfectly finished works. A newly discovered entry in the diary of Lady Charlotte Finch recording her order on 6 September 1764 of 'a Telemachus Dress for the Prince of Wales and a Turk's for Prince Frederick', and noting the arrival of the dresses two days later when the princes put them on, provides a dating for the group in the autumn of 1764. (O. Hedley, *op. cit.,* kindly communicated by Sir Oliver Millar.)

The room in which the Queen sits is her dressing-room, on the first floor of the garden front of Buckingham House. It was one of the suite of apartments newly decorated and furnished by George III for his consort. This picture and no. 24, appear to be the first of Zoffany's many conversation groups portrayed in interior settings; his earlier groups are in landscape or stage settings. The room has been altered and rearranged by the painter, for Mrs Lybbe Powys (*Passages from the diaries,* p. 116), who had the rare privilege of inspecting the Queen's apartments on 23 March 1767, records that her dressing-room was hung with crimson damask, into which were let impressions and miniatures. No doubt Zoffany felt that such a background was too heavy and distracting for his composition. He may also have introduced the carpet, for Mrs Lybbe Powys describes the floors as 'all inlaid in a most expensive manner'. By contrast, the toilet-table and gilt toilet-service probably reproduce these objects more or less as they appeared in actuality, for Mrs Lybbe Powys mentions: 'On her toilet, besides the gilt plate, innumerable knick-knacks'. The sumptuous toilet-table cover has been identified as the 'suit of [Superfine Flanders point] Lace to Cover a Toilet Table Compleat' supplied by Priscilla MacEune, Lacewoman at a cost of £1,079 14s in 1762. (K. M. Walton, *op. cit.;* kindly communicated by Mr Peter Thornton.) The silver-gilt toilet-service is not now among the royal plate: it seems to be of German, perhaps Augsburg make, rather than of English workmanship and may have been brought by the Queen from Strelitz.

Further rooms in the suite, hung with pictures and a long pier-glass, are seen through the open door, by which stands a French long-case clock attributed to Charles Cressent and still in the Royal Collection.

Together with the *Portrait of George, Prince of Wales, and Prince Frederick* (no. 24), this exceptionally charming group marks the inauguration of the informal royal conversation piece as a genre.

Her Majesty Queen Elizabeth II

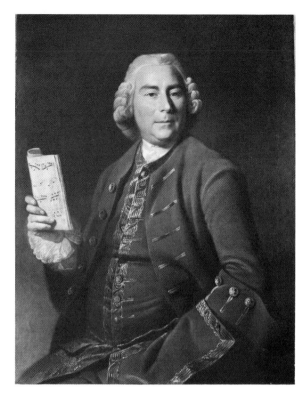

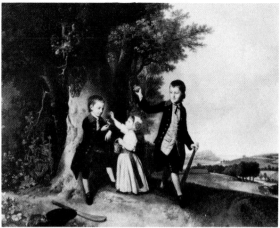

26 Stephen Rimbault 1764

Canvas, 89×71 (35×28)
An old label on the back reads: *By Johann Zoffany 1764*

Provenance: painted for the sitter, by descent to Mrs A. Aslett by whom bequeathed to the Tate Gallery 1929.
Literature: J. T. Smith, *Nollekens and his Times*, ed. W. Whitten, II, 1920, pp. 67–8.

John Stephen Rimbault (working 1744–88) was a famous clockmaker of Huguenot descent. He carried on business in Great St Andrew's Street, St Giles, making musical clocks with painted dials and moving figures dancing or working in front of a suitably decorated background. To prick the barrels Rimbault employed an Italian musical box maker named Bellodi who is said to have introduced Zoffany, then reduced to living in a garret in Bellodi's house, to the clockmaker. For a short time Zoffany painted the decorative faces of Rimbault's musical clocks.

Family tradition states that Rimbault introduced Zoffany to the portrait painter Benjamin Wilson, who employed him to paint figures and draperies at £40 a year; in gratitude Zoffany painted this portrait of Rimbault. In the 1820s the portrait hung over the chimney-piece in the front parlour of the house of the sitter's nephew, Stephen Francis Rimbault, the organist and collector of Rowlandson's drawings.

The Trustees of the Tate Gallery

27 The Sondes children *c.* 1764–5

Canvas, 96.5 × 122 (38 × 48)

Provenance: by descent.

The sitters are the sons of the Hon Lewis Monson-Watson, 1st Lord Sondes, and his wife Grace, daughter of the Rt Hon Henry Pelham. The eldest, Lewis (April 1754–1806), stands holding a cricket bat and ball, while Henry (April 1755–1833) and Charles (October 1761–1769) are offering nuts to a pet squirrel. Zoffany has made a lively and attractive composition of the children grouped in front of a tree with a wide landscape stretching away to the right. On the ground lies a cricket bat, showing the early form with a curved end.

The ages of the children indicate a date of 1764–5 for the picture. (C. Wise, *Rockingham Castle and the Watsons*, 1891, Genealogical table.)

Commander Michael Watson

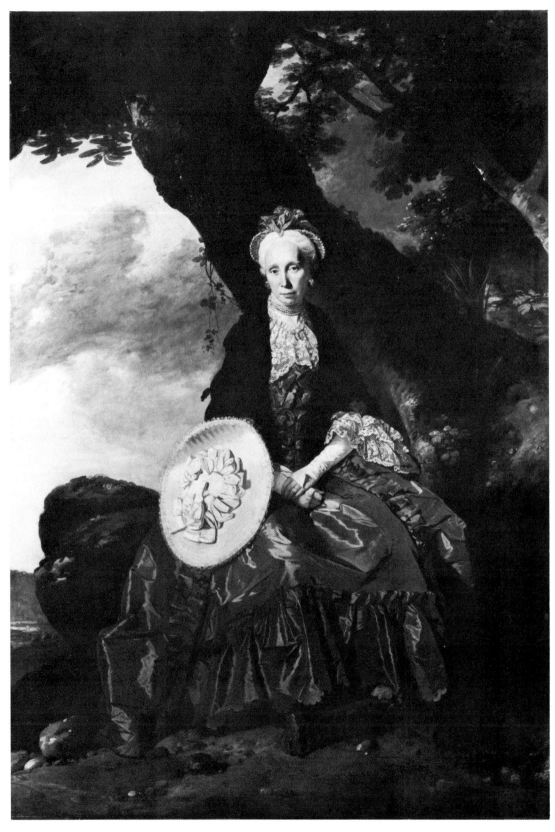

28 Mrs Oswald c. 1764–5

Canvas, 226.5 × 159 (89¼ × 62½)

Provenance: by descent, Oswald sale Christie's 14 June 1922 (106); Lord Lee, from whom purchased 1938.
Exhibition: R. A., *British Art*, 1934 (237).
Literature: M. Davies, *The British School* (National Gallery Catalogues), 1959, pp. 111–12.

Mrs Oswald is seated, apparently on a rock, beneath a tree, a wide-brimmed hat suspended from her arm. Mary (d. 1788), only daughter and heiress of Alexander Ramsay of Jamaica, married Richard Oswald (1710–84) in 1750. Robert Burns, whose poetic wrath was roused by being moved on from an inn into the bad weather by the arrival of her funeral procession, wrote a bitter ode to her memory. Richard Oswald was a highly successful merchant and politician who came to London about the time of his marriage. Among the lands he bought in Ayrshire and Galloway was the estate of Auchincruive, which he purchased in 1764 and where he built a house.

This fine full-length portrait, datable by the costume to c. 1765, may have been painted to commemorate the acquisition of Auchincruive, which crowned Oswald's ambition to found an estate, for it is known to have hung in this house. The seam in the finely painted blue drapery is a characteristically literal touch.

National Gallery, London

29 Edward Shuter in 'Love in a Village' (c. 1765)

Mezzotint by John Finlayson, 1768
45.5 × 56 (18 × 22)

Edward Shuter as Justice Woodcock, John Beard as Hawthorn and John Dunstall as Hodge in Isaac Bickerstaff's ballad opera *Love in a Village*. The first performance was at Covent Garden on 8 December 1762 with the actors shown here. Several versions of this composition are known: two show a painting of the *Judgement of Solomon* on the wall behind the figures, as in the engraving (Private collection; Detroit Institute of Arts), and in a third is a copy of Van Dyck's group portrait of the *Children of Charles I* (Shakespeare Memorial National Theatre Trust).

National Portrait Gallery, London

30 James Thornton (c. 1765)

Mezzotint by R. Houston, 1770
33 × 22.9 (13 × 9)

Literature: C.S., p. 690, no. 116.

James Thornton, the King's gardener at Kew.

Victoria and Albert Museum

31 John, 3rd Duke of Atholl, and his family 1765–7

Canvas, 93.5 × 158 (36¾ × 62¼)

Provenance: painted for the sitter, by descent.
Exhibitions: English Conversation Pieces, 1930 (6); R.A., *European Masters of the Eighteenth Century*, 1954–5 (123); Arts Council, *Johann Zoffany*, 1960 (12).

John, 3rd Duke of Atholl, KT (1729–74), married in 1753 his first cousin, Lady Charlotte Murray (1731–1805), who on the death of her father, the 2nd Duke of Atholl, in 1764 succeeded to the Barony of Strange and sovereignty of the Isle of Man. Zoffany has portrayed the Duke and Duchess grouped informally with their family beside the Tay in the grounds of their seat at Dunkeld. Next to his father, proudly holding a fish-hook and a fish, is their eldest son, John, Marquess of Tullibardine, later 4th Duke (June 1755–1830). Grouped by their mother, who sits on a green wooden garden seat with platform attached, are the eldest daughter, Lady Charlotte Murray (August 1754–1808), holding a garland of roses, and, on the ground, Lady Amelia (July 1763–1806), offering a red rose to the Duchess, who holds on her lap the baby Lady Jane (December 1764–1846). At the end of the garden seat holding up a branch is Lord William (March 1762–1796), still wearing an infant's 'coat'; Lord George (January 1761–1803), proud of his new suit, is guarding a pile of hats. Having thrown his coat over the back of the seat Lord James (December 1757–1770) is perched

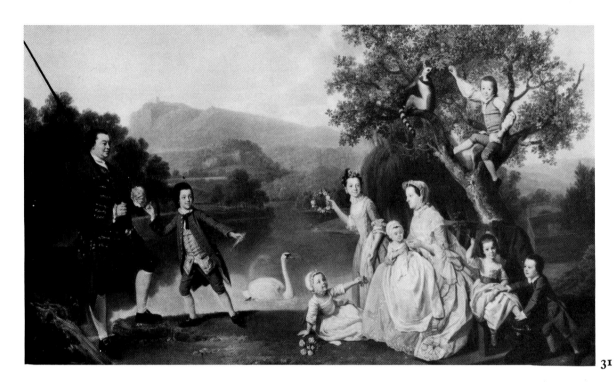

in the apple tree. The animal beside him represents Tom the racoon, one of many exotic animals, birds and curiosities sent back from the West Indies by Admiral James Murray; Tom lived at Blair Castle in a cage specially made for him in a window on a staircase. Tom did not, however, sit for his portrait – Zoffany has painted a lemur, not a racoon. This is one of the few pictures by Zoffany for which a payment is known. As was customary, it was paid for in two parts – when it was begun in June 1765 and when completed in January 1767. Zoffany's receipt specifies that he charged twenty guineas a figure.

Having succeeded his uncle in January 1764, the Duke was soon busily engaged in making improvements to his estates. During the summer of that year he built the pillar on the top of Craig Vinian, seen in the background of the picture to the left of the Atholl Cairn, and he began a wall enclosing part of Craig a Barns with a view to planting it. Early in November he set out for London with the Duchess and his family to negotiate the disposal of their sovereignty of the Isle of Man to the British Government. On 2 December in London the Duchess gave birth to a daughter, Lady Jane.

The Duke and Duchess continued the remodelling and refurbishing of Blair Castle begun by the Duchess's father, the 2nd Duke. To fit the overmantel of the great drawing-room on the second floor Zoffany was commissioned to paint this family group in the summer of 1765. It can be assumed that he began work when the first payment was made in June; it is clear from the ages of the children that he laid in the figures and the draperies, presumably finishing at least the heads, before the family returned to Dunkeld in August 1765. Apart from Lord Tullibardine and his brother Lord James, who were at school in Kensington in January 1766, the Duke and Duchess and their family remained in Scotland, not returning to London until the beginning of November 1766. It has been suggested that the identifiable features of the background were put in by Charles Stewart, who was painting decorative landscapes for the dining-room at Blair Castle in the second half of the 1760s. The style of the background is however perfectly compatible with Zoffany's and is unlike Stewart's work at Blair. The chief objection to Zoffany's having painted the landscape – that he never went to Scotland – is easily overcome, for it would have been simple for drawings of the landscape to have been sent or brought by the Duke in November 1766 and given to Zoffany for him to incorporate their features into his picture. The background and finishing touches were undoubtedly put in during the visit of the Duke and Duchess to London and before 16 January 1767 when Zoffany signed the receipt for payment. (John, Seventh Duke of Atholl, *Chronicles of the Atholl and Tullibardine Families*, IV, 1908, pp. 5–40.) The composition is a very clever solution to the problem of arranging lucidly and with due emphasis the members of a large family group. Unity is imposed by the skilful use of parallel slanting lines and by an artful blend of symmetry and balance.

The Duke of Atholl

32 Mr and Mrs Dalton and their niece Mary de Heulle *c.* 1765–8

Canvas, 90.8×71 (35¾×27 15/16)

Provenance: presumably painted for Richard Dalton and his wife; first recorded in the will of John Landon, Mrs Dalton's brother-in-law, in 1796; Capt Samuel Landon, by descent to the Revd John Primatt Maud; Christie's 31 May 1902 (68), bt. 'A.W.'; the Hon Frederick Wallop by 1920, by descent to Alan Evans by whom bequeathed to the National Gallery 1974, transferred to the Tate Gallery.
Exhibition: Conversation Pictures, 1930 (58).
Literature: Tate Gallery Report, 1974–6 (forthcoming).

Richard Dalton (?1715–91) draughtsman and antiquarian, travelled in 1749 to Greece, Constantinople and Egypt, and was the first Englishman to publish drawings of monuments of ancient art from those countries. He became Librarian to George III, by whom he was sent in 1763 to Italy to make a collection of drawings and medals; at the same time Dalton played an important part in building up the King's collection of books and Italian pictures. (M. Levey, *The Later Italian Pictures in the Royal Collection*, 1964, pp. 28–30, 35–6.) After his return he was appointed Keeper of the King's drawings and medals; in 1778 he became Surveyor of the King's pictures. Regarded as a rather equivocal figure by his contemporaries, he was however closely connected with the early history of the founding of the Royal Academy, and from 1770 to 1784 held the honorary post of Antiquary to the Academy.

Holding a tatting-shuttle is Dalton's wife Esther (d. 1782), the daughter of a wealthy Huguenot Spitalfields silk-weaver, whom he married in 1764; their young niece Mary de Heulle is beginning a copy under Dalton's tuition of the drawing of the *Spinario* which he holds. Mary was the daughter of Mrs Dalton's brother Abraham de Heulle (d. 1763) and his wife Mary Magdalen Garnault, whom he married in 1758; she was apparently orphaned young and brought up by the Daltons who had no children of their own. She is shown here at the age of about six or seven years, presumably shortly after her adoption by the Daltons. The picture may be dated *c.* 1765–8 on grounds of style, costume and probable date of birth of Mary de Heulle.

With its conventional curtain and arbitrary spatial construction the background is now at variance with the elaborate Turkey carpet, and there are signs which suggest that perhaps a more realistic background was originally intended. Not all parts of the picture are equally finished. John Landon (1767–1847), a relation of Mrs Dalton, and himself an amateur artist, commented that 'the likeness of Dalton is wonderful'.

During the indirect family descent of the picture the identity of the sitters was lost; it was entitled *The Drawing Lesson* and was said to portray members of the Palmer Family. (Manners & Williamson, pp. 155, 242, 308.) (I am indebted to Miss Elizabeth Einberg for kindly communicating the history of the picture and the identification of the sitters.)

The Trustees of the Tate Gallery

33 David Garrick in 'Lethe' 1766

Canvas, 100.3 × 124.5 (39½ × 49) (withdrawn)

Provenance: Robert Alexander, sale Christie's 31 March 1775 (67) bt. in; Christie's 6 March 1776 (76); Sir George Beaumont, by descent, sale Sotheby 30 June 1948 (52); purchased with the aid of the NA-CF.
Exhibitions: Arts Council, *Johann Zoffany*, 1960 (16); Arts Council, *The Georgian Playhouse*, 1975 (29).
Literature: Birmingham City Art Gallery Catalogue, p. 158.

The farce of *Lethe* or *Aesop in the Shades* was written by Garrick and first performed in 1740. A popular afterpiece, *Lethe* was put on by Garrick for Rousseau's visit to Drury Lane on 23 January 1766. The cast were the actors depicted here: Garrick as Lord Chalkstone, Ellis Ackman as Bowman and Astley Bransby as Aesop. Bowman is asking: Does your Lordship propose a wager as proof of the goodness of your head? (see no. 34).

Birmingham City Museums and Art Gallery

34 Astley Bransby as Aesop in 'Lethe' (1766)

Mezzotint by John Young, 1788
51 × 61 (20 × 24)

Astley Bransby as Aesop, William Parsons as the Old Man and Watkins as the Servant in *Lethe*. See no. 33, to which the original of this mezzotint is a companion (Birmingham City Museums and Art Gallery).

Private collection

35 John, 14th Lord Willoughby de Broke, and his family 1766

Canvas, 100.5 × 125.5 (39½ × 49½)

Provenance: painted for the sitter, by descent.
Exhibitions: S.A., 1769 (215) (identified by Walpole); R.A., *British Art*, 1934 (242); R. A., *European Masters of the Eighteenth Century*, 1954–5 (108); R.A., *British Portraits*, 1956–7 (360); Arts Council, *Johann Zoffany*, 1960 (5).

John Verney, 14th Lord Willoughby de Broke (1738–1816), and his wife Lady Louisa North (1737–98), sister of the famous Prime Minister Lord North, with their three eldest children in the breakfast-room at Compton Verney. The children are John, later 15th Baron (June 1762–1820), George (June 1763–1773) and Louisa (January 1765, died young). On the evidence of the age of the children the picture can be dated 1766; the sons are not yet breeched – the fashionable age for breeching was about four – and the little girl is being supported by her mother. The costumes of the parents accord with a date in the mid-1760s.

Lord Willoughby de Broke was a Lord of the Bedchamber and he may have been influenced in the choice of a painter for his family group by Zoffany's two royal conversation pictures (nos. 24 and 25) which show a very similar degree of informality and precision. The crisp and accurate rendering of the still-life details on the table, the draw-string of the curtain, the intricate pattern and texture of the carpet, the fireplace and gilt-framed landscape above, complement the action in which Zoffany gives the appearance of having transfixed a lively domestic moment. The elder son is running to the table pulling his wooden horse, while his father lifts a warning finger to prevent the untimely seizing of a piece of toast by the younger brother. Their small sister is under the control of their mother who has moved sideways to grasp her. The painting is noticeable for the skill with which the informal action is brought within the classical composition of the figures as a triangle, drawing the eye upwards; the portraits are placed before a plain background. This balance of plain and patterned, still-life and movement, demonstrates how carefully Zoffany worked out the composition.

20th Baron Willoughby de Broke

36 Andrew Drummond 1766

Canvas, 213.5 × 183 (84 × 72) oval

Provenance: by descent.
Engraving: mezzotint by James Watson, not dated (from a private plate; C. S., p. 1505, no. 48).

Exhibitions: B.I., 1855 (105); National Portrait Gallery, *Treasures and Curiosities, Drummonds at Charing Cross*, 1968.

Andrew Drummond (1688–1769), founder of Drummond's Bank, is seated beside his dog on a garden seat placed under a tree on rising ground. In his left hand, which rests on his hat, he holds a snuff-box, in the other he clasps his Malacca cane with a gold crutch handle.

The younger son of Sir John Drummond of Machany, Andrew Drummond arrived in London soon after the Union, with ten guineas in his pocket. He began business as a goldsmith and in 1717 opened a second ledger as a banker. The success of his thriving bank at Charing Cross, though assisted by his family connections with the Scottish aristocracy, was also due to his strict probity, sound sense and industry. To the many Scottish customers of the bank, Jacobites, kinsmen, friends and merchants, were soon added a wide variety of the fashionable, political, musical and artistic world. Zoffany opened an account at the bank in 1765.

In 1716 Andrew Drummond married Isabella Strahan, by whom he had a son and a daughter. He purchased an estate at Stanmore in Middlesex in 1729 and it was there that Zoffany later painted a conversation group of the family (Mellon Collection), in which he included a reduced copy of the portrait exhibited here.

A payment of £136 10s 0d was made in 1766 by Andrew Drummond for this fine full-length portrait, in which the sitter is so strongly characterised.

The Royal Bank of Scotland Ltd

37 Hester Maria Thrale (1766)

Mezzotint by G. Marchi, not dated

51.5 × 35.7 (20¼ × 14)
Literature: C.S., p. 916, no. 13.

Hester Maria Thrale (September 1764–1857), 'Queeney', eldest daughter of Henry Thrale and Mrs Thrale, the friends of Dr Johnson, with whom she was a great favourite. She married, as his second wife, Admiral Lord Keith in 1808.

Queeney was painted at the age of twenty months in the spring of 1766. Mrs Thrale, who was urged by her mother, Mrs Salusbury (see no. 38), to begin Queeney's education at an early age, recorded: 'she knew 15 of her letters when she was 15 months old, at 20 months she so astonished Zoffany to whom she sat for her picture that he told the King of her odd Performances'. (*Thraliana*, ed. K. C. Balderston, I, 1942, p. 308.)

The present whereabouts of the portrait from which this engraving was made is unknown.

The Trustees of the British Museum

38 Mrs Salusbury *c.* 1766

Canvas, 127 × 101.5 (50 × 40)

Provenance: Mrs Piozzi, by descent.
Exhibition: Conversation Pieces, 1930 (69).
Literature: A. Hayward, *Autobiography of Mrs Piozzi*, I, 1861, p. 219; G. E. Ambrose, *Catalogue of the Collection of Pictures belonging to the Marquess of Lansdowne*, 1897, p. 135.

Hester Maria Salusbury (1707–73), daughter of Sir Thomas Cotton, married 'her flashy cousin John' Salusbury (1707–62). After her fortune had been used up their difficulties and desperate schemes for making money flit across the pages of the writings of her celebrated daughter, Mrs Thrale, later Mrs Piozzi.

Mrs Salusbury is portrayed as a widow standing in an entrance hall, holding a sealed document in her right hand, and in her left a large white silk handkerchief. The portrait on the wall of a gentleman wearing a blue coat and red waistcoat is surely that of her husband. The brown and white spaniel is the same dog as in the portrait of her granddaughter, Queeney (no. 37); presumably the two pictures were painted at about the same time.

Spending most of her widowhood with her daughter, Mrs Thrale, Mrs Salusbury was chiefly interested in current news and topics and was at first on terms of mutual dislike with Johnson, who thought this a waste of time. Towards the end of her life her feelings for Johnson turned to admiration, and he wrote her a flattering epitaph.

Bowood Collection

39 Brook, John and Harry Young c. 1766

Canvas, 86.5×63.5 (34×25)
Inscribed in a later hand: *Brook, John and Harry Young/Zoffany and Stubbs pinx 1770*

Provenance: by descent.

Perhaps a study for no. 41. The three younger sons of Sir William Young, with a negro page. Brook was at Eton from 1762 to 1766. (R. A. Austen-Leigh, *The Eton College Register 1753–1790*, 1921, p. 582).

Some differences in pose, costume and background suggest that this and no. 40 are studies for the large group of the whole family; they are thus amongst the very few known examples which show how Zoffany worked up the composition of his conversation pieces.

Sir William Young, Bt

40 William Young and his sister Mary c. 1766

Canvas, 63.5×49.5 (25×19½)

Provenance: by descent.

Perhaps a study for no. 31. William Young, FRS, FSA (1749–1815), succeeded his father as 2nd Baronet in 1788. Author, poet and amateur artist, he was educated at Eton (1758–67) and Oxford, where he matriculated in 1768.

He travelled widely in Europe, including a journey to South Italy with his friend Charles Towneley (see no. 95), before becoming an MP (1784–1807). He was Governor of Tobago from 1807 until his death. After selling the estate of Delaford in 1790 he rented Hartwell House until his departure for Tobago.

Sir William Young, Bt

41 The family of Sir William Young c. 1766

Canvas, 114.5×167.5 (45⅛×66)

Provenance: painted for the sitter, by descent to Julian Young, Christie's 14 December 1928 (96); Sir Philip Sassoon, Christie's 2 July 1937 (34).
Exhibitions: English Conversation Pieces, 1930 (7); Kenwood, The Iveagh Bequest, *The Conversation Piece in Georgian England,* 1965 (49).

Sir William Young, 1st Baronet (1725–88), holding a 'cello, is seated beside his second wife Elizabeth (1729–1801), who is being 'assisted' in playing the theorbo by their youngest daughter Olivia. Sitting on a stone wall on the right is William, 2nd Baronet (1749–1815), and his favourite sister Mary who holds a letter. Three daughters are grouped behind their mother: Sarah Elizabeth, who married Richard Ottley on 12 June 1770, holds a music book; next are Elizabeth and Portia with flowers. At the left on horseback is Brook, wearing a plumed hat, and the youngest son John (baptised 10 September 1761 at

St John's, Antigua), held up by a negro page; Henry stands playing with a dog.

Sir William Young, whose parents, William Young of Leny and Margaret Nauton of Antigua, lived in the West Indies, married as his second wife, in 1747, Elizabeth, only child of Brook Taylor, of Bifrons, Kent, Secretary to the Royal Society. Their eldest son William was born at Charlton, Kent, two years later. (G.E.C., *Complete Baronetage,* V, 1906, p. 153; R. A. Austen-Leigh, *The Eton College Register 1753–1790,* 1921, p. 583.) In 1767 William Young purchased the manor of Delaford, Buckinghamshire; on 8 March 1768 he was appointed Lieutenant-Governor of St Dominica, and on 18 October 1770 Lieutenant-Governor of Tobago. He resigned in 1774 or early 1775. (T. Southey, *Chronological history of the West Indies,* II, 1828, pp. 398, 406, 421; Vere L. Oliver, *The History of the Island of Antigua,* III, 1899, pp. 280–4.) He was created a baronet on 3 May 1769. The presence of the negro servant is explained by the family's West Indian connection.

William Young and his wife were friends of Garrick, from whom they tried to borrow scenery and costumes for a private production of *Julius Caesar* in 1758. (*The Letters of David Garrick,* ed. D. M. Little and G. M. Kahrl, I, 1963, nos. 208, 209.) The Van Dyck costume in which they are portrayed is therefore particularly appropriate. The skilful use of this fancy dress, then at the height of its popularity, makes this picture one of the most romantic of English rococo conversation pieces. It could almost be called an English domestic version of the French *fête champêtre* as inspired by Boucher. The motif of the boy on horseback recalls Dutch seventeenth-century painting.

Instead of returning to the West Indies in 1768 to take up his appointment as Lieutenant-Governor of St Dominica, William Young and his family remained in England until at least the summer of 1770, when his eldest daughter married. (*The Letters of David Garrick, op. cit.,* II, no. 596.) This is the latest possible date for the picture, which was thought to have been painted about the time of the baronetcy. However, a date of *c.* 1766 is more probable in view of the age of the youngest son John, at the left, and the youthful appearance of the eldest son William, on the far right, whose Eton leaving portrait by Benjamin West of 1767 may have been painted slightly later. (L. Cust, *Eton College portraits,* 1910, no. 12, pl. viii.) The dates of birth of the other children are not recorded. (E. Kimber and R. Johnson, *The Baronetage of England,* III, 1771, p. 251.) Probably 'my family picture at the old Road' bequeathed by Sir William 'To Billy Young my grandson'. (Vere L. Oliver, *op. cit.,* p. 281.)

Walker Art Gallery, Liverpool

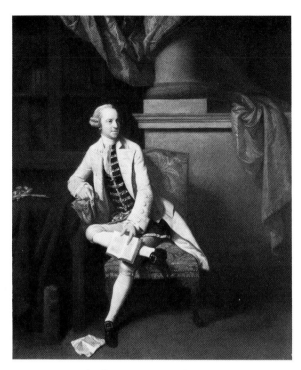

42 Mr Gawler's cousin *c.* 1767

Canvas, 76.2×63.5 (30×25)

Provenance: Cavendish Collection; London art market 1968.

The sitter is only known as the cousin of John Gawler (1727–1803), an attorney, of Weyhill, Hampshire, and of Burridge House, Southampton. The folio books in the bookcase and on the floor may indicate a connection with the legal profession.

In this carefully contrived small whole-length portrait Zoffany has posed his sitter in a characteristically lively manner which animates the highly conventional setting. The chair can be recognised as Zoffany's 'sitter's chair', which appears in several portraits (eg nos. 32, 51).

Mr and Mrs Paul Mellon, Upperville, Virginia

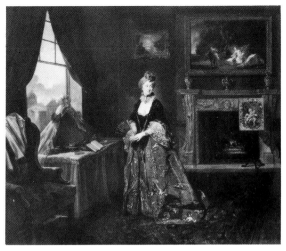

43 Mrs Abington in 'The Way to Keep Him' 1768

Canvas, 99×113 (39×44½)

Provenance: probably bought by the 3rd Earl of Egremont from W. Smart 1823, by descent.
Exhibitions: Wildenstein & Co, *Works of Art from Petworth House*, 1954 (24); T. Agnew & Sons, *English Pictures from National Trust Houses*, 1965 (8); Brussels, *Europalia*, 1973 (73).
Literature: C. H. Collins Baker, *Catalogue of the Petworth Collection of Pictures*, 1920, no. 659.

Mrs Abington (1737–1815) as the Widow Bellmour in *The Way to Keep Him* (Act II (later III) Scene i), by Arthur Murphy, a role she made famous. One of the most popular of Murphy's comedies, *The Way to Keep Him* was first produced at Drury Lane in 1760 in three acts. The author subsequently enlarged it to five acts and in 1785 dedicated it to Mrs Abington. She played the part of the Widow Bellmour on the occasion of her benefit at Drury Lane on 6 April 1768.

The scene Zoffany has painted takes place in 'a Room at the Widow Bellmour's, in which are disposed up and down, several chairs, a Toilette, a Bookcase . . .', and begins with the Widow reading aloud from a volume of Pope. The moment shown is when on finishing her reading she says to her maid, 'Here, Mignionet, put this Book in its Place'.

This portrait of the famous actress Frances Abington, whose professional reputation was firmly established by the early 1760s, had lost its identification by 1837 when it was listed in an Egremont inventory simply as 'an actress'. Comparison with other portraits of Mrs Abington and the role in which she is shown leaves no doubt about the identification.

Some features in this composition derive from the two royal conversation groups painted in 1764 (nos. 24 and 25). The *garniture de cheminée* of three Derby vases dates from *c.* 1768 (kindly communicated by Mr T. Clifford).

The National Trust (Egremont Collection, Petworth)

44 Edmund Keene, DD (1768)

Mezzotint by Charles Turner, 1812
47.6×35 (18¾×13¾)

Literature: A. Whitman, *Charles Turner*, 1907, p. 116, no. 285.

Edmund Keene, DD (1714–81), Master of Peterhouse 1748–54 and Rector of Stanhope, Durham, was Bishop of Chester 1752–71 and Bishop of Ely from 1771 until his death. The present whereabouts of this portrait, painted in 1768 when Keene was Bishop of Chester, is unknown.

The Trustees of the British Museum

45 A Porter with a Hare 1768

Canvas, 78×62 (30¾×24½)
Inscribed on the label attached to the hare: *zu Zaffaly* [?]; on back of stretcher: *Zafani*

Provenance: Ernest Cook, bequeathed to the NA-CF, 1955, presented to Coventry.
Engraving: mezzotint by Richard Earlom, 1774; in colour, 1780.
Exhibitions: perhaps S.A., 1769 (213); Walker Art Gallery, *Gifts to Galleries*, 1968 (97).

A genre scene in the Dutch taste, this was a most popular composition. There are several contemporary versions of the picture, which was exhibited at the Society of Artists in 1769. Walpole described it as 'admirable' and stated that it was taken from 'Nature'. (*Walpole Society*, XXVII, 1938–9, p. 83.)

The boy with a bag slung over his shoulder is reading the direction on the label to the porter, who cups his hand to his ear, while the boy eating bread and butter points out the way.

Herbert Art Gallery and Museum,
Coventry District Council

46 A Porter with a Hare c. 1768–9

Canvas, 73.5×61 (29×24)
Inscribed on the label attached to the hare: *Mr Zoffany L[incoln's] Inn Fields*

Provenance: Duke of Marlborough; Christie's 1 June 1956 (55).
Exhibition: Arts Council, *Johann Zoffany*, 1960 (7).

See no. 45. A good example of this much admired composition. Zoffany moved in 1765 to the address on the label attached to the hare.

The Hon Mrs Whitfield

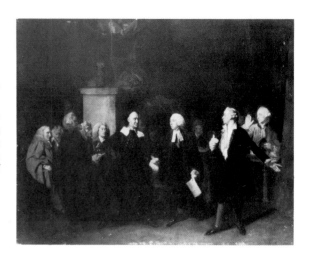

47 Macklin as Shylock in 'The Merchant of Venice' c. 1768

Canvas, 116.2×151 (45¾×59½)

Provenance: Dominic Colnaghi; Lord Orford, sale Christie's 28 June 1856 (249); Marquess of Lansdowne; presented to the Tate Gallery by the NA-CF.
Engraving: single figures of Macklin as Shylock and Clarke as Antonio engraved by John Smith, 1769.
Exhibitions: Suffolk Street, 1832 (89); South Kensington, *National Portrait Exhibition*, 1867 (806); *English Conversation Pieces*, 1930 (78).
Literature: *Art Journal*, 1 August 1856, p. 251; G. E. Ambrose, *Catalogue of the Collection of Pictures belonging to the Marquess of Lansdowne*, 1897, no. 275; R. Mander and J. Mitchenson, *The Artist and the Theatre*, 1955, pp. 56–8.

The trial scene from *The Merchant of Venice* (Act IV Scene i), probably based on performances at Covent Garden in the season of 1767–8. Charles Macklin (1690/99?–1797), left centre, first played Shylock at Drury Lane in 1741 and gave a new interpretation of the part, portraying Shylock as a serious rather than a low comedy figure. In this he was most successful and made the role very much his own, playing it for the last time in 1789. Bassanio, on the left, is played by Robert Bensley (1742–1817), and Portia, in the centre, by Maria Macklin (c. 1732–81), the daughter of Charles. On the right are Antonio, with bared chest, played by Matthew Clarke (fl. 1755–83) and Gratiano by Michael Dyer (d. 1774). In the background seated on a dais is the Duke, played by David Morris (d. 1777); at the foot of the dais are Nerissa and the clerk.

The moment represented is almost certainly that which immediately precedes the famous crisis of the scene when Shylock refuses to listen to Portia's pleas for mercy and charity, and Antonio has bared his chest and awaits the knife.

Zoffany has given the scene a setting which is a curious mixture of Venice and England. Seated on a raised chair, his elbow resting on a cippus supporting

the lion of St Mark, is the Doge (Shakespeare's Duke), wearing a Doge's cap. Below the Doge, at a semi-circular table covered with green baize, sit three figures; the one in yellow on the right is Gratiano.

A curiosity of Zoffany's picture is that he has represented Shakespeare's magnificos of Venice by four English judges dressed in their legal robes of scarlet; scarlet was also the colour of the robes of Venetian senators. Among them on the extreme left he has depicted the characteristic profile of William Murray, Lord Mansfield. The reason for the inclusion of Mansfield's portrait is not apparent. He may have been introduced because of his great fame as a judge; alternatively he may have commissioned the painting – a representation of this most celebrated of theatrical trial scenes might well have had a special appeal for him. The picture is unfinished.

The Trustees of the Tate Gallery

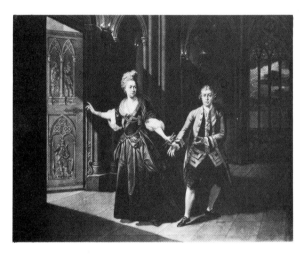

48 Garrick and Mrs Pritchard in 'Macbeth' (1768)

Mezzotint by Valentine Green, 1776
41.9 × 55.2 (16½ × 21¾)

Literature: C.S., p. 554, no. 47.

Mrs Pritchard as Lady Macbeth points to Duncan's chamber; in her left hand she holds the daggers. Garrick as Macbeth appears 'a moving statue, or indeed a petrify'd man . . . the murderer should be seen in every limb'. (Arts Council, *The Georgian Playhouse*, 1975 (41).) Celebrated as a tragic actress, Mrs Pritchard (1711–68) is shown here in her most famous role. She appeared for the last time on the stage as Lady Macbeth, with Garrick, on 24 April 1768 at Drury Lane. The painting (Maharajah of Baroda) from which this mezzotint was scraped was probably executed at the time of her last performance. 'When She seized the instruments of death, and said, "Give me the Daggers!" her look and action . . . will not soon be forgotten by the surviving spectators.' (T. Davies, *Memoirs of the Life of David Garrick*, II,

1780, p. 184). The background, remarkable at this period, is Zoffany's one known attempt at the Gothick and the sublime, but it presumably reproduces the original stage-set which may have been influenced by Walpole's *Castle of Otranto*, published in 1765. Its interest appears not to have been recognised by historians of taste.

National Portrait Gallery, London

49 Giacomo Cervetto *c.* 1768–70

Canvas, 127 × 97.8 (50 × 38½)

Provenance: Sir John Smith-Marriott.
Engraving: mezzotint by Mrs Victor Marie Picot (formerly Miss Angelique Ravenet), 1771. Exhibited S.A., 1771 (288). Hitherto recorded as the only known mezzotint by her husband (C.S., p. 998).
Exhibition: T. Agnew & Sons, *Art Historians as Critics and Collectors*, 1965 (2).

Giacomo Cervetto (Basevi) (1682–1783), of Venetian-Jewish origin, was a leading 'cellist of his age. He came to England in 1738 and became a member of the band at the Drury Lane Theatre, where he was often encouraged by shouts from the gallery to 'play up, Nosey'. He annoyed Garrick by yawning loudly during one of the actor's performances, but excused himself by saying he always did this when 'very mush please'. He published sonatas for the 'cello. He died at Fribourg's Snuff Shop in the Haymarket at the age of 101.

This portrait, which is unfinished, shows Zoffany's humorous appreciation of character and strong affinity for music and musicians. The eye is led straight to the masterful hand fingering the strings and thence to the carefully modelled head. Cervetto's gaze is concentrated on the music book, its leaves falling back from the stand, a corner turned down. The details are painted with Zoffany's customary crisp precision.

Edward Croft-Murray, Esq

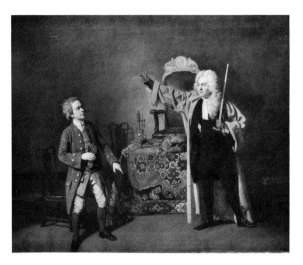

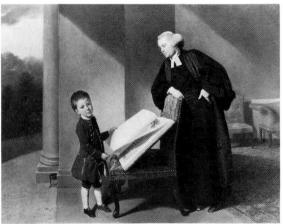

51 The Reverend Randall Burroughes and his son Ellis 1769

50 Samuel Foote in 'The Devil Upon Two Sticks' *c.* 1768–9

Canvas, 101.6 × 128.3 (40 × 50½)

Provenance: presumably painted for Foote; George Colman, sale Christie's 3–4 August 1795 (94); bt. Woolmer, sale Christie's 7 May 1796 (107), bt. Bryan for the Earl of Carlisle. (Kindly communicated by Mr J. Kerslake.)
Engraving: mezzotint by J. Finlayson, 1769.
Exhibitions: S.A., 1769 (214); Arts Council, *The Georgian Playhouse*, 1975 (25).

Foote's satire on the medical profession, *The Devil Upon Two Sticks*, was first produced at the Haymarket Theatre on 30 May 1768. Foote played the Devil (the President, Dr Hellebore), a part alluding to the loss of his leg two years before, He was celebrated as a mimic actor, here taking off Sir William Browne (President of the Royal College of Physicians 1765–6), with the exact counterpart of his wig, glass, coat and odd figure. Sir William sent Foote a card complimenting him on the representation, but as Foote had forgotten the muff he sent him his own. (G. Wolstenholme and D. Piper, *The Royal College of Physicians of London, Portraits*, 1964, p. 92).

In the scene represented the Devil exclaims to Dr Last, played by Thomas Weston (1737–76), for whom the part was written: '. . . in the midst of a violent struggle (by which means I got this lame leg, and obtained the nickname of the Devil Upon Two Sticks) the Daemon of Vanity, a low under-strapper amongst us, held over his head a circle of gold, with five knobs on the top, and, whew! flew away with our prize in an instant'. (Act I Scene iii).

Zoffany has painted the carpet, the muff and microscope with great sensitivity and attention to detail.

Private collection

Canvas, 71 × 89 (28 × 35)
Inscribed on the relining canvas: *J. Zoffany 1769*

Provenance: by descent to Miss Amy Burroughes of the Manor House, Long Stratton (d. 1933); Miss Streatfield; Dr Colgate, by descent to Sir Eardley Holland; Sotheby 18 November 1970 (35).
Exhibitions: probably S.A., 1769 (219); T. Agnew & Sons, *Painting in England*, 1973 (22).

The Reverend Randall Burroughes of Long Stratton, second son of Jeremiah Burroughes of Burlingham, was a member of a noted Norfolk family; he married an heiress, Elisabeth Maria Ellis of Kidhall. Their son Ellis (1764–1831), here portrayed at the age of five, is turning the pages of a volume of Joshua Kirby's *Perspective of Architecture*, 1761, showing the frontispiece and a page with a triumphal arch (identified by Mr John Harris). Zoffany owned a copy of the book, and Kirby, who was elected President of the Society of Artists in 1768, was a personal friend and neighbour.

Private collection, USA

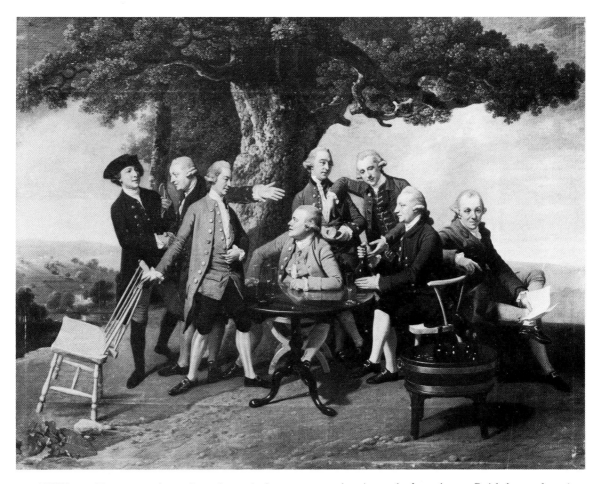

52 William Ferguson introduced as heir to Raith 1769

Canvas (five pieces sewn together), 106 × 131.5 (41¾ × 51¾)

Provenance: by descent.
Exhibitions: National Gallery of Scotland 1946–53; R.A., *British Portraits*, 1956–7 (334); Arts Council, *Johann Zoffany*, 1960 (11).

The young man at the left wearing a hat and carrying a riding crop is William Berry, who is being warmly welcomed by his uncle, Robert Ferguson of Raith (1690–1781), into a convivial group gathered round a table on a hill-top. Apart from Zoffany, who is seated on the right, the other sitters are not identified; it is suggested that one may be Robert Adam of Blairadam and the others neighbouring friends. The landscape background is said to represent the view from Raith of the Forth and surrounding hills. Against such identifications is the inclusion of Zoffany, which suggests that this may be a circle of London, rather than of Scottish friends.

Robert Ferguson acquired a large fortune in the East India trade and bought the estate of Raith in 1723. He married Mary Townsend of Honnington in 1725, but instead of moving to Raith he preferred to remain in the City, living over his counting-house at Austin Friars until his death. He had no children and his immediate heir was Robert Berry, eldest son of his sister. This nephew, whose 'careless disposition' and literary interests conflicted with business, did not further ingratiate himself by marrying a portionless beauty who produced two daughters – later celebrated in intellectual and political society – Mary and Agnes Berry (no. 70). Thus Robert Berry's youngest brother William, after working in a London mercantile house, was employed by his uncle in looking after his accounts in Scotland. He proved his abilities and in November 1768 became heir to his uncle's fortune. At this time Robert Ferguson established William in the house in Fifeshire, and made him direct his estate and all his affairs in Scotland. William married an heiress, Jane, second daughter of Ronald Crawford of Restalrig, and was soon further favoured by the birth of two sons, Robert (1770–1840) and Ronald (1773–1841). On succeeding to the estate William Berry assumed by royal licence, 12 January 1782, the surname and arms of Ferguson.

According to tradition Zoffany has depicted the convivial occasion of William being introduced as heir to his uncle. The costume and style accord with

the date 1769. Some features of this picture, generally admired as one of Zoffany's finest conversation pieces, are unexplained; for instance what is the document held by Zoffany and why is he pointing to it? Moreover the picture was clearly enlarged and altered while the artist was working on it. The action of Robert Ferguson seems to suggest a hearty invitation to his nephew to join the group of friends, and the whole scene may be a little more informal in its meaning than tradition suggests. The difficulty of interpreting the picture illustrates the essentially intimate nature of conversation pieces and the importance of family history in elucidating them. (J. Ferguson and R. M. Ferguson, *Records of the Clan and Name of Fergusson*, Edinburgh, 1895, pp. 311–20; *Extracts from the Journals and Correspondence of Miss Berry*, ed. Lady Theresa Lewis, I, 1866, pp. 1–4; private information.)

A. B. L. Munro Ferguson of Raith and Novar

53 George, 2nd Earl of Bristol (1769)

Mezzotint by James Watson, not dated
50.5 × 35.5 (19⅞ × 14)

Literature: C.S., p. 1494, no. 15.

George William Hervey, 2nd Earl of Bristol (1721–75) succeeded his grandfather in 1751. Ambassador at Madrid in 1759, he withdrew in December 1761 after the renewal of the 'Family Compact' between France and Spain, an offensive and defensive alliance of the House of Bourbon which led to the declaration of war between England and Spain. He was Lord-Lieutenant of Ireland 1766, Keeper of the Privy Seal October 1768–70 and Groom of the Stole 1770.

On the chair to Lord Hervey's right is the bag embroidered with the royal coat of arms in which the Seal was kept. The portrait at Ickworth after which this mezzotint was scraped can therefore be dated 1769, during his period of office as keeper of the Privy Seal. (I am indebted to Mr Claude Blair for kindly identifying the Seal Bag.)

The National Trust (Ickworth, Suffolk)

54 Caritas Romana *c.* 1769

Canvas, 76.3 × 63.5 (30¼ × 25⅛)
Signed: *J. Zoffany inv*

Provenance: presumably Robert Hamilton, sale Ed. Foster 15 March 1832 (190); purchased for Felton Bequest 1931–2.
Literature: U. Hoff, *European Paintings before Eighteen Hundred*, National Gallery of Victoria, 1967, p. 144.

The subject of *Roman Charity*, taken from Valerius Maximus, V, 4, was extremely popular with late Renaissance and baroque painters.

Perhaps painted *c.* 1769, at about the time Zoffany became interested in genre scenes. He may have used for his models the same figures as in *Beggars on the road to Stanmore* (no. 55).

National Gallery of Victoria, Melbourne, Australia

55 Beggars on the road to Stanmore *c.* 1769–70

Canvas, 91.5 × 76 (36 × 30)

Provenance: by descent.
Exhibitions: probably R.A., 1771 (232); B.I., 1840 (101); National Portrait Gallery, *Treasures and Curiosities, Drummonds at Charing Cross*, 1968.

The beggar and his family are grouped at the roadside by a milestone. The old man, who kneels, is a most dignified portrayal; the hat on the ground in front of him contains a single penny. The child, his ragged clothes and shoes several sizes too large, bringing a silver coin to comfort his mother, shows all Zoffany's observation of detail, while the mother's garments are patched and worn, though her pink shawl and jaunty straw hat add a cheerful note. According to contemporary tradition in the Drummond family the figures are portraits taken from the life of beggars on the road to Stanmore, where Andrew Drummond (no. 36) had a country house.

The group was probably painted about 1769–70, at the same time as the conversation picture of three generations of the Drummond Family (Mellon Collection). At about this date Zoffany produced several closely observed genre scenes (see no. 45) which aroused much favourable comment. The arrangement of the figures derives from compositions of The Holy Family with St John.

Cadland Settled Estate

56 Sir Lawrence Dundas with his grandson 1769–70

Canvas, 101.5 × 127 (40 × 50)

Provenance: by descent.
Exhibitions: R.A., *European Masters of the Eighteenth Century*, 1954–5 (115); Bowes Museum, 1962 (11).
Literature: W. R. Juynboll, *Oud-Holland*, LXV, 1950, p. 162; D. Sutton, 'The Nabob of the North', *Apollo*, LXXXVI, no. 67, 1967, pp. 168–9; A. Coleridge, 'Sir Lawrence Dundas and Chippendale', *Apollo, cit.*, pp. 190–203; A. Coleridge, 'Some Rococo Cabinet makers and Sir Lawrence Dundas', *Apollo, cit.*, pp. 214–25; J. Fowler and J. Cornforth, *English Decoration in the 18th Century*, 1974, pp. 96, 106–7, 126, 128.

Sir Lawrence Dundas (*c.* 1710–81), who belonged to the impoverished branch of an old Scottish family, set up as a merchant and contractor, made a large fortune and played a significant political role. He became Commissar General of the Army in Scotland, Flanders and Germany, speculated successfully on the Stock Exchange, and as a Governor of the Royal Bank of Scotland 1764–77 steered the bank through a critical period. He was created a baronet in 1762, and was MP for Edinburgh 1768–81.

A most discerning patron of the arts, Sir Lawrence made great improvements to his properties at Aske, Moor Park, and 19 Arlington Street, London. Zoffany's portrait of him with his grandson Lawrence (April 1766–1839), who was created 1st Earl of Zetland in 1838, shows the sitters in the library or pillar room at 19 Arlington Street, when Adam's alterations to the house had been completed and the new decorations and furniture installed. This most fascinating interior gives accurate details of pictures, objects, furniture, curtains and treatment of walls, as well as evidence for the methods Zoffany employed in composing the settings for his conversation groups.

The contents of the library at Arlington Street listed in an inventory taken in May 1768 are:

A Chimney Board
A Turkey Carpet
2 Morine Window Curtains
A Pier glass in a gilt frame
A large mahogany Library table
A smaller D°.
A large mahogany pediment Book Case and an alabastar vauze on D°.
A smaller Book Case
2 Mahogany Presses
A Mahogany 2 flap table
A large gilt 5 flap Screen
A french Elbow Chair in horse hair
5 Back stools in leather
A Wind Dial
4 Pictures
2 Branches screw'd to the Chimney
A Square Trunk

In addition, '350 feet of Gadroon Border Richly Gilt

in Oil Gold' had been supplied for the library by Samuel Norman, cabinet-maker and carver, between 1763 and 1766.

An examination of the picture shows that Zoffany has included this gilt fillet set off against the newly fashionable plain bright wallpaper and following the line of the chimney-piece. Of the items listed in the inventory he has selected: the chimney board, Turkey carpet, and reefed moreen curtains; to their left the pier-glass in its gilt frame hangs above the large mahogany library-table (now at Aske); by Sir Lawrence is the mahogany two-flap table. Here the actual contents cease and Zoffany's alteration of the room, turning it into a cabinet, begins.

The chimney-piece may have been in the library; one of a very similar design, but with a pediment above the central mask, was in the gallery (*Country Life*, 1921, p. 353). Certainly the splendid sea-piece, *Shipping Becalmed* by Jan van de Cappelle (now at Aske), did not hang above it, for the inventory lists '2 Branches screw'd to the Chimney'. William France, cabinet-maker, who also specialised in the sale of lamps and brasswork, charged 1s 6d in December 1764 for 'Taking down the two branches from front of the Chimney, [in the Gallery?] and putting up on the Chimney in the Library'. France was hanging

pictures in the house in March 1764, including two in the library; for this he used special brass-headed nails, some with carved heads, of various sizes and weights to suit the pictures. Such nails are shown by Zoffany above several of the eleven pictures he has included. The frames of four more pictures – one is reflected in the mirror – bring the total number in his composition to fifteen, whereas we know that only four were hanging in the room. The bronzes on the chimney-piece and on the library table are not known to have been in the library. Bookcases have been banished and the books under the pier-glass are the only allusion to the actual function of the room.

This clearly documented example of Zoffany's methods of composing his settings, seen already in the two royal conversation groups (nos. 24, 25), and later in a considerably more complex manner in *The Tribuna* (no. 76) and *Charles Towneley's Library* (no. 95), was quite obviously not only an accepted, but possibly an expected or dictated formula for portraying a sitter amongst his chosen possessions. Here Sir Lawrence is portrayed in his house, newly decorated in the elegant Adam style, among his new furniture and recently acquired pictures, his eldest grandson beside him. It would be unrealistic to suggest that in this method of composition Zoffany took unwarranted liberties.

Either at his patron's suggestion, or at his own, Zoffany has shown Sir Lawrence as a connoisseur of the arts, rather than among the literary and scholarly associations of a library.

It is probable that the payment of £105 made by Sir Lawrence to Zoffany on 26 June 1770 was for this conversation piece.

The Marquess of Zetland

57 Thomas King and Mrs Baddeley in 'The Clandestine Marriage' *c.* 1769–70

Canvas, 94 × 125.5 (37 × 49½)

Provenance: Charles Matthews, whose collection was purchased by the Garrick Club 1835.
Engraving: mezzotint by R. Earlom, 1772.
Exhibitions: R.A., *British Art*, 1934 (238); R.A., *European Masters of the Eighteenth Century*, 1954 (125); R.A., *Bicentenary Exhibition 1768–1968*, 1968–9 (14).
Literature: C. K. Adams, *A Catalogue of Pictures in the Garrick Club*, 1936, no. 23; D. Mannings, 'Gainsborough's Duke and Duchess of Cumberland with Lady Luttrell', *The Connoisseur*, CLXXXIII, 1973, pp. 92–3.

Thomas King (1730–1805) as Lord Ogleby, Mrs Sophia Baddeley (1745–86) as Fanny Sterling and Robert Baddeley (1733–94) as Canton in *The Clandestine Marriage* by Garrick and Colman. The Baddeleys married in 1764, and although they separated three years later they continued to act together.

Canton recommends Fanny to Lord Ogleby and, in the following scene where Fanny joins them, her application to Lord Ogleby on behalf of one she loves is misconstrued as an amorous address. The Baddeleys and King, who was the original Lord Ogleby, were cast for the Command Performance of the play at Drury Lane on 12 October 1769, where Mrs Baddeley raised a universal laugh in this scene. Lord Ogleby: 'Oh, thou amiable creature! Command my heart for it is vanquished' (Act IV). The following day Mrs Baddeley was 'honoured with a message from their Majesties . . . to go to Zophany's and to be taken for her picture in that attitude and situation'. (Elizabeth Steele, *The Memoirs of Mrs Sophia Baddeley*, I, 1787, p. 16.)

The Garrick Club

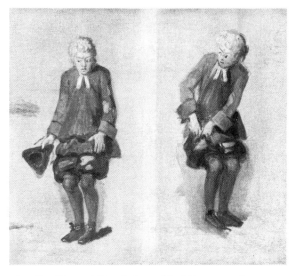

58 Studies of Garrick as Abel Drugger in 'The Alchymist' *c.* 1769–70

Canvas, 33 × 38 (13 × 15)

Provenance: probably William Alexander FSA, sale Sotheby 27 February 1817 (1260); Chambers Hall by whom given to the Ashmolean Museum, 1855.

Two studies of Garrick for no. 59, in which Zoffany has sketched the actor's attitudes in the most lively manner. One of the few preliminary oil sketches by Zoffany that have been identified.

The Visitors of the Ashmolean Museum

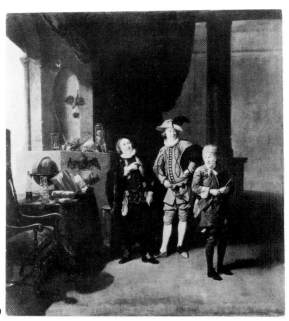

59

59 Garrick with Burton and Palmer in 'The Alchymist' 1770

Canvas, 104×99 (41×39)

Provenance: purchased for a hundred guineas by Sir Joshua Reynolds who sold it to the Earl of Carlisle for the same sum on condition that he gave the additional twenty guineas he was offering Reynolds to Zoffany.
Exhibitions: R.A., 1770 (212); B.I., 1840 (81); *English Conversation Pieces*, 1930 (81).
Engravings: mezzotint by John Dixon, 1772; the single figure of Garrick by John Dixon, 1791.

Subtle, the Alchemist, played by William Burton (d. 1774), wearing a doctor's cap and gown, is telling the sign of Abel Drugger who has come to consult him. Drugger, played by Garrick, holds the pipe of tobacco he has brought in payment. John Palmer (1747–98) as Face, standing between them, watches Drugger with amusement. *The Alchymist* by Ben Jonson, Act II, last scene. The play was performed at Drury Lane on 22 November 1769. Abel Drugger, a Tobacco Man, was one of Garrick's famous roles. He described his interpretation of it in his *Essay on Acting*, 1744, as 'the compleatest low picture of Grotesque Terror that can be imagin'd by a Dutch painter'.

Walpole's comment, 'This most excellent picture ... is one of the best pictures ever done by this genius', reflected the universal acclaim. Mary Moser wrote to Fuseli in Rome, describing the exhibition at the Royal Academy '. . . . and Zoffany superior to everybody, in a portrait of Garrick in the character of Abel Drugger, with two other figures, Subtle and Face. Sir Joshua agreed to give a hundred guineas for the picture; Lord Carlisle half an hour after offered Reynolds twenty to part with it, which the Knight generously refused, resigned his intended purchase to the Lord, and the emolument to his brother artist. (He is a gentleman!).' (J. T. Smith, *Nollekens and his Times*, I, 1829, pp. 62–3.)

Private collection

60 Master James Sayer 1770

Canvas, 89×68.5 (35×27)

Provenance: by descent, Sotheby 31 July 1934 (118).
Engraving: mezzotint by R. Houston, 1772, published by the sitter's father (C.S., p. 686, no. 109).

According to the inscription on the engraving the portrait was painted in 1770 when the sitter was thirteen years old. James Sayer was the son of Robert Sayer (d. 1794), the well-known print publisher of the second half of the eighteenth century. A most charming and characteristic example of Zoffany's small whole-length portraits.

Private collection

61 George III, Queen Charlotte and their six eldest children (1770)

Mezzotint by R. Earlom, 1770
50.8×59 (20×23¼)

Literature: C.S., p. 248, no. 15.

The Royal Family in Van Dyck costume. His arm resting on a plinth, the King stands by Queen Charlotte who holds on her lap the infant Princess Augusta. Princess Charlotte takes the baby's hand. To the left of the King stand George, Prince of Wales, and Prince Frederick. Prince William plays with a cockatoo, and Prince Edward, wearing an infant's 'coat', holds a tiny spaniel. The painting from which this mezzotint was scraped was exhibited at the Royal Academy in 1770 (211); it is in the Royal Collection. (O. Millar, *Later Georgian Pictures in the Collection of Her Majesty The Queen*, 1969, no. 1201.)

National Portrait Gallery, London

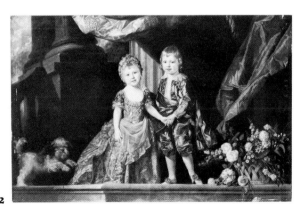

62

62 Charlotte, Princess Royal, and Prince William, later Duke of Clarence and William IV *c.* 1770

Canvas, 132.4×200 (52⅛×78¾)

Provenance: presumably painted for George III or Queen Charlotte.
Literature: O. Millar, *Later Georgian Pictures in the Collection of Her Majesty The Queen*, 1969, no. 1204.

Charlotte, Princess Royal (1766–1828), and Prince William, later William IV (1765–1837), standing on a stone ledge under a colonnade. The Prince, wearing Van Dyck costume, holds his sister by the hand. The canvas originally extended some 34.3 cm (13½ in) at the top, showing full silk curtains, and 8.9 cm (3½ in) at the bottom, with a rose trailing down from the basket of flowers on the right. This portrait and its companion of *George, Prince of Wales, and Prince Frederick* (Millar, *op. cit.*, no. 1203) were presumably painted early in 1770 at about the same time as the group of George III, Queen Charlotte and their six eldest children in Van Dyck costume (see no. 61). The placing of the sitters behind the front of the ledge, and the raised front paws of the dog may indicate that this delightfully decorative picture was originally intended to be hung above eye-level.

Her Majesty Queen Elizabeth II

63 Frederick, Duke of York *c.* 1770

Canvas, 184.1×153.7 (72½×60½)
Signed: *John Zoffany Pinxt.*

Provenance: painted for George III or Queen Charlotte.
Literature: O. Millar, *Later Georgian Pictures in the Collection of Her Majesty The Queen*, 1969, no. 1205.

Wearing a military coat and the ribbon of the Bath, Prince Frederick (see nos. 24 and 25), second son of George III and Queen Charlotte, stands in a landscape. This charming portrait of the young Duke of York originally included to the right of the figure a large drum and a huge suit of seventeenth-century armour, decorated with a long flowing sash, apparently painted out at an early date. They are still present on a replica of this portrait in the collection of S.K.H. Prince Ernst August.
Presumably painted *c.* 1770.

Her Majesty Queen Elizabeth II

64 Mrs Wodhull (*c.* 1770)

Mezzotint by R. Houston, 1772
50.5×35.5 (19⅞×14)

Literature: C.S., p. 692, no. 124.

Catherine Ingram (1744–1808) married Michael Wodhull, the distinguished bibliophile and translator of Euripides, in 1761. A life-size classicising portrait in the manner made so fashionable by Reynolds. The painting from which this mezzotint was scraped is in the collection of Dr D. M. McDonald and is now on loan to the Tate Gallery. (R. Gibson, *An exhibition of paintings from the collection of Dr D. M. McDonald*, Leggatt Bros, 1970 (39).)

National Portrait Gallery, London

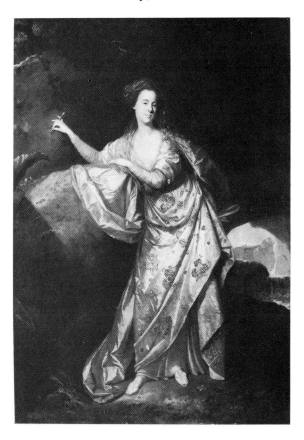

65 Portrait of an actress *c.* 1770

Canvas, 218×158.5 (86×62½)

The identification of the sitter of this fine life-size portrait of an actress is lost, and the role she plays is uncertain. She stands leaning on a rock in a cave, holding a graver in her right hand, with which she is presumably about to engrave the name of her lover on the rock. The clasp on her shoulder bears the profile portrait of a man. In the background at the right is a waterfall.

It has been suggested that the sitter may be Miss Ann Brown, later Mrs Cargill (drowned 1784), a singer, mainly connected with Covent Garden, in the role of Miranda in *The Tempest* or *The Enchanted Island*. From comparison with the portrait of Mrs Wodhull (see no. 64) the picture is dated *c.* 1770; the embroideries on the costume are treated similarly to those on the dress worn by Mrs Abington (no. 43).

The Marquis de Lastic, Paris

66 George III (1771)

Mezzotint by R. Houston, 1772
53.6×40 (21⅛×15¾)

Literature: C.S., p. 660, no. 43.

George III, seated, wearing a General Officer's coat, with the ribbon and star of the Garter. The painting from which this mezzotint was scraped was exhibited at the Royal Academy in 1771 (230); it is in the Royal Collection. (O. Millar, *Later Georgian Pictures in the Collection of Her Majesty The Queen*, 1969, no. 1195.)

The Trustees of the British Museum

67 Queen Charlotte (1771)

Mezzotint by R. Houston, 1772
53.6×40.3 (21⅛×15⅞)

Literature: C.S., p. 653, no. 25.

Queen Charlotte, seated, wearing a richly laced dress and a black shawl. A miniature of George III is set into the pearl bracelet on her wrist. The painting from which this mezzotint was scraped dates from 1771 and is a companion to the portrait of George III (see no. 66); it is in the Royal Collection. (O. Millar, *Later Georgian Pictures in the Collection of Her Majesty The Queen*, 1969, no. 1196.)

The Trustees of the British Museum

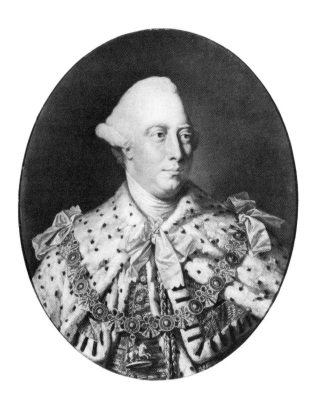

68 George III *c.* 1771–2

Copper, 78.1×63.5 (30¾×25) oval

Provenance: James Cox 1772, Cox's Museum disposed of by lottery 1773 (50); purchased by Her Majesty Queen Mary.
Literature: O. Millar, *Later Georgian Pictures in the Collection of Her Majesty The Queen*, 1969, no. 1197.

The head is related to the life-size threequarter-length portrait of George III which Zoffany painted in 1771 (see no. 66). By contrast with the informality of that portrait the King is shown here in the panoply of state, wearing an ermine mantle and the insignia of the Garter. This picture, and its companion of Queen Charlotte (no. 69), can be identified as two portraits painted by Zoffany for Cox's Museum. James Cox, a jeweller of Spring Gardens, Charing Cross, issued in 1772 *A Descriptive Catalogue of the . . . superb and magnificent pieces of Mechanism and Jewellery* exhibited in his museum (reference kindly communicated by Mr Michael Snodin). The most splendid item was 'a Throne of gold thirty-two feet in circumference' on which were two altars with the royal cyphers and 'a band of mechanical music, playing upon kettledrums, trumpets and other instruments, various fine pieces, concluding with God save the King; . . . vases filled with flowers of jeweller's work . . . containing musical machines and mechanical motions, by which the flowers unfold, and insects move like life'. On the wall above the throne were 'pictures of their Majesties, painted by Mr Zoffanii on ovals of copper; those Royal

Portraits are magnificent beyond description, they are placed in frames of metal finely wrought and richly gilt, from whence issue numberless rays, forming a glory or irradiation like beams of the sun . . . suspended from above by genii over each picture are imperial resplendent crowns, embellished with jewels and pearls, placed under a canopy of crimson velvet bordered, fringed and tasselled, with gold and adorned with pearls; upon the ceiling of which, and in front is a glory formed of glass and gold'.

Her Majesty Queen Elizabeth II

69 Queen Charlotte *c.* 1771–2

Copper, 77.5×65.1 (30$\frac{1}{2}$×25$\frac{5}{8}$) oval

Provenance: see no. 68.
Literature: O. Millar, *Later Georgian Pictures in the Collection of Her Majesty The Queen*, 1969, no. 1198.

Related to the life-size threequarter-length portrait of Queen Charlotte which Zoffany painted in 1771 (see no. 67). The companion portrait to no. 68, *q.v.*

Her Majesty Queen Elizabeth II

70 Mary and Agnes Berry *c.* 1771–2

Canvas, 182.8×152.5 (72×60)

Provenance: presumably painted for the sitters, by descent.
Engraving: steel by H. Adlard, frontispiece to *Journals and Correspondence of Miss Berry*, ed. Lady Theresa Lewis, I, 1866.

Mary Berry (March 1763–1852), seated on a stone garden roller, and her sister Agnes (May 1764–1852). With their widowed father, Mary and Agnes Berry moved from Yorkshire to College House, Chiswick, in the spring of 1770. Robert Berry brought his family to London to try to court the favour of his uncle Robert Ferguson who had disinherited him (see no. 52). In this he failed, and with much bitterness Mary records in her *Journal* that they lived on an allowance of £300 a year. However, after the death of their uncle in 1781, Robert's younger brother William settled on him an annuity of £1000 a year. With his two daughters Robert Berry travelled abroad from 1783 to 1785. Soon after their return they made the acquaintance of Horace Walpole, who maintained an affectionate correspondence with the sisters. In 1791 they moved to Walpole's house, Little Strawberry Hill, which he later bequeathed to them. Walpole entrusted them with his literary remains, and in 1798 the *Works of Horace Walpole* appeared, nominally edited by Robert Berry, but in reality by Mary. Among her other publications were Madame du Deffand's letters from the originals at Strawberry Hill and *Social Life of England and France from 1660–1830.*

Although they may appear older, the two little girls in their newly fashionable feathered caps are portrayed here at the age of eight or nine; the seemingly large-scale dog indicates their relative height. A charming example of Zoffany's few life-size portraits of children, painted about 1771–2 when the Berrys were neighbours of the artist at Chiswick.

A. B. L. Munro Ferguson of Raith and Novar

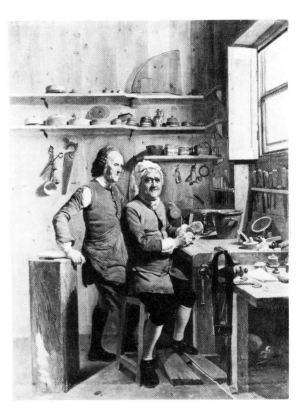

71 John Cuff and an assistant 1772

Canvas, 89.5×69.2 (35$\frac{1}{4}$×27$\frac{1}{2}$)
Signed and dated on leg of work bench: *Zoffanij pinx / 1772*

Provenance: presumably purchased by, or painted for George III or Queen Charlotte.
Exhibitions: R.A., 1772 (291); R.A., *King's Pictures*, 1946–7 (504); R.A., *British Portraits*, 1956–7 (353); Detroit and Philadelphia, *Romantic Art in Britain*, 1968 (39); The Queen's Gallery, *George III Collector and Patron*, 1974–5 (52).
Literature: O. Millar, *Later Georgian Pictures in the Collection of Her Majesty The Queen*, 1969, no. 1209.

John Cuff, seated at his work-bench polishing a lens, was an optician whose shop was at the sign of the 'Reflecting Microscope, exactly against Serjeants' Inn Gate, Fleet St.'. Master of the Spectacle Makers' Company in 1748, Cuff perfected inventions and made

important improvements in microscopes. He sold microscopes to George III and Queen Charlotte. Standing behind is his assistant who wears a leather apron and sleeves. His tools are on the bench and on the racks and shelves beside him.

A highly finished picture in the Dutch manner, whose still-life details are painted with sympathetic precision. Zoffany's experience of painting stage scenes is perhaps visible in the vivacious expression of the two figures. This picture is exceptional for the period in that it represents Cuff in his working clothes and in his workshop. Hence it partakes far more of the nature of the genre scene than of the true portrait, and for this reason it may have been commissioned by the King or Queen rather than by Cuff himself. The tradition of depicting virtuoso techniques was one that went back to the late Renaissance. We know that the aristocratic Walpole found its Dutch fidelity to nature distasteful; in a famous criticism he commented: 'extremely natural, but the characters too common nature, and the chiaroscuro destroyed by his servility in imitating the reflexions of the glasses'. In this last comment Walpole fixes unerringly on Zoffany's technique of building up an impression of verisimilitude by the skilful juxtaposition of accurate detail rather than by broadly conceived effects of light and shade.

Her Majesty Queen Elizabeth II

72 Prince Ernest, later Duke of Cumberland 1772

Canvas, 91.4×70.2 (36×27⅝)

Provenance: presumably painted for George III or Queen Charlotte.
Literature: O. Millar, *Later Georgian Pictures in the Collection of Her Majesty The Queen*, 1969, no. 1206.

Seated on a red cushion, Prince Ernest (June 1771–1851) is shown as a baby of about eight months. From this unfinished portrait it is possible to see how Zoffany worked up his compositions; this is especially interesting as few drawings or preliminary studies for portraits have survived. There are several *pentimenti* in the folds of the dress and in the right hand, which may be holding a shoe; the position of the right foot has also been altered. The forms of the draperies are carefully laid in and the shadows well defined.

Painted in the early months of 1772, the portrait was left unfinished, perhaps on account of Zoffany's plans for a voyage round the world with Banks and Solander in the spring of that year, and his eventual departure for Italy in July.

Her Majesty Queen Elizabeth II

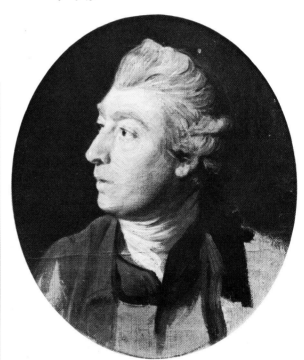

73 Thomas Gainsborough *c.* 1772

Canvas, 19×17 (7⅝×6⅝) oval

Provenance: said to have been given by Zoffany to Gainsborough, or to his daughter Margaret; Mr Briggs; Miss Clarke; Richard Lane ARA, a great-nephew of Gainsborough's, the Misses Lane by whom presented to the National Gallery 1896.

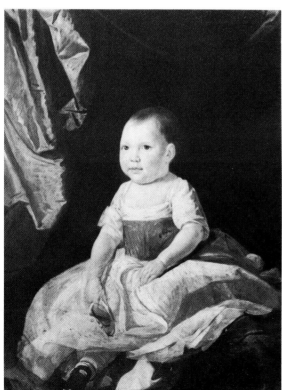

72

Exhibitions: B.I., 1859 (166); *National Portrait Exhibition*, 1867 (518); R.A., *Old Masters*, 1887 (19).
Literature: M. Davies, *The British School* (National Gallery Catalogues), 1946, p. 183; J. Hayes, *The Drawings of Thomas Gainsborough*, 1970, no. 238.

Thomas Gainsborough (1727–88), founder member of the Royal Academy, the celebrated landscape and portrait painter.

According to tradition in Gainsborough's family, this striking unfinished portrait is the best likeness of him. When Zoffany was painting the Academicians (no. 74), Gainsborough, who is not represented in the group, was living in Bath; it would seem probable on stylistic grounds that Zoffany made this study in connection with the group of the Academicians exhibited in 1772, possibly during one of Gainsborough's visits to London. Whether it was painted too late to be included or whether Gainsborough preferred, like Dance, to be omitted is not known. The absence of the two from the group may be connected with Walpole's note about the 1773 exhibition: 'Gainsborough and Dance, having disagreed with Sir Joshua Reynolds, did not send any pictures to this exhibition'. (G. W. Fulcher, *Life of Thomas Gainsborough*, 1856, p. 81.)

The Trustees of the Tate Gallery (on loan to the National Portrait Gallery, London)

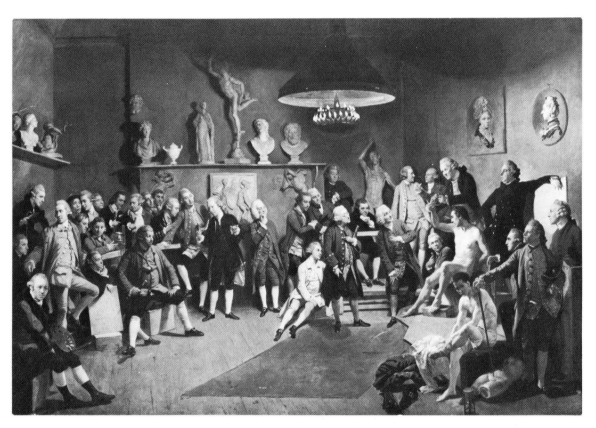

74 The Academicians of the Royal Academy
1771–2

Canvas, 100.7 × 147.3 (39¾ × 58)

Provenance: presumably painted for George III.
Engraving: mezzotint by Richard Earlom, 1773 (C.S., p. 243).
Exhibitions: R.A., 1772 (290); R.A., *Bicentenary Exhibition 1768–1968*, 1968–9 (12) with further references; The Queen's Gallery, *George III Collector and Patron*, 1974–5 (34).
Literature: O. Millar, *The Later Georgian Pictures in the Collection of Her Majesty The Queen*, 1969, no. 1210; S. C. Hutchison, *The History of the Royal Academy*, 1968, pp. 42–62.

On 14 January 1771 the rooms in Old Somerset House that George III had made available to the Royal Academy School were opened in the presence of the Duke of Cumberland, the Academicians and Associates. They included a lecture room, a plaster academy and a life room where two men sat each night for two hours – by the hour-glass (Whitley I, pp. 273–6). In his group of the assembled Academicians Zoffany has combined casts from the plaster academy with the living models in his celebration of the Royal Academy, newly founded by George III, as 'the most superb of

any in the world'.

Since the Renaissance it had been customary to hold the life class and to teach drawing from casts by lamplight in order to assist students to learn modelling by throwing up the forms of the body in strong relief of light and shade.

When exhibited at the Royal Academy in 1772 it was recorded as the picture which drew 'the densest crowd about it', and Walpole later wrote of it: 'This excellent picture was done by candlelight; he made no design for it, but clapped in the artists as they came to him, and yet all the attitudes are easy and natural, most of the likenesses strong.' Studies of eight Academicians by Charles Grignion, who was a student at the Academy, are said to have been made at the same time as the sitters were being painted by Zoffany. (M. Kemp, *Dr William Hunter at the Royal Academy of Arts*, Glasgow, 1975, p. 14, no. 5.)

Apart from Gainsborough (see no. 73) and George and Nathaniel Dance all the Academicians are present. George Moser, the Keeper whose duty it was to look after the Schools and servants, is arranging the model under the supervision of Francesco Zuccarelli, one of the first of the Visitors who were appointed 'to attend the Schools by rotation, each a month, to set the figures, to examine the performances of the Students . . .', and of Richard Yeo the medallist, whose pointing hands indicate the desired turn of the model's arm. Hand raised to his chin, William Hunter (see no. 75), Professor of Anatomy, considers the pose. Next to Hunter, holding his ear trumpet, stands Sir Joshua Reynolds, the first President, in conversation with Sir William Chambers, Treasurer, and Francis Milner Newton, Secretary. Francis Hayman, Librarian, is seated immediately to their left. Cane in hand on the right is 'The Macaroni Painter' Richard Cosway; on the wall behind are the portraits of the two female Academicians, Angelica Kauffmann and Mary Moser, who were excluded from the presence of nude models. Zoffany has represented himself, palette in hand, seated at the left.

Her Majesty Queen Elizabeth II

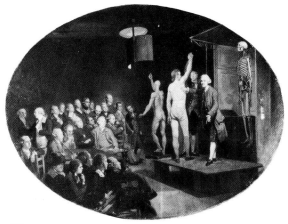

75

75 William Hunter lecturing at the Royal Academy *c.* 1772

Canvas, 77.5 × 103.5 (30½ × 40¾) oval

Provenance: bequeathed to Hunter's nephew and heir, Dr Matthew Baillie, presented by Mrs Baillie 1823.

Literature: G. Wolstenholme and D. Piper, *The Royal College of Physicians of London, Portraits*, 1964, p. 232; M. Kemp, *Dr William Hunter at the Royal Academy of Arts*, Glasgow, 1975, pp. 14–19.

Dr William Hunter (1718–83), appointed as first Professor of Anatomy at the Royal Academy in 1768, giving a demonstration before an audience of artists and students. Standing on a wooden platform, Hunter has posed his model in an attitude similar to that of the plaster *écorché* figure on the left, in order to show the formation of the muscles; a skeleton is suspended in a wooden cubicle behind him.

Apart from Sir Joshua Reynolds, who is seated in the centre and holds an ear trumpet, no member of the audience has been identified.

William Hunter first studied in Glasgow and Edinburgh; he came to London in 1741 where from 1746 onwards he began to lecture, firstly in surgery and later in anatomy for which he became renowned. Hunter became a licentiate of the College of Physicians in 1756 and from then on built up a busy practice in midwifery. He was first consulted by Queen Charlotte in 1762, later being appointed Physician-Extraordinary to the Queen. In 1768 he moved into a house in Great Windmill Street, on which he spent much time and money. He fitted it up with an amphitheatre and apartments for lectures and dissections, and with a magnificent room as a museum, which housed his outstanding collection of anatomical and natural history specimens, medals and a very fine library. In 1774 he published his monumental work, *The Anatomy of the Gravid Uterus*.

This picture, which is unfinished, was probably painted after the group of the Academicians of the Royal Academy (no. 74) in which the same *écorché* figure appears. The demonstration would thus be taking place in the lecture room at Old Somerset House. The great popularity of the group of the Academicians when it was exhibited in the spring of 1772 may have led Zoffany to contemplate a second composition in the same vein, particularly as Hunter's demonstrations were immensely successful. Zoffany's departure for Italy in July perhaps accounts for the picture remaining unfinished.

Royal College of Physicians

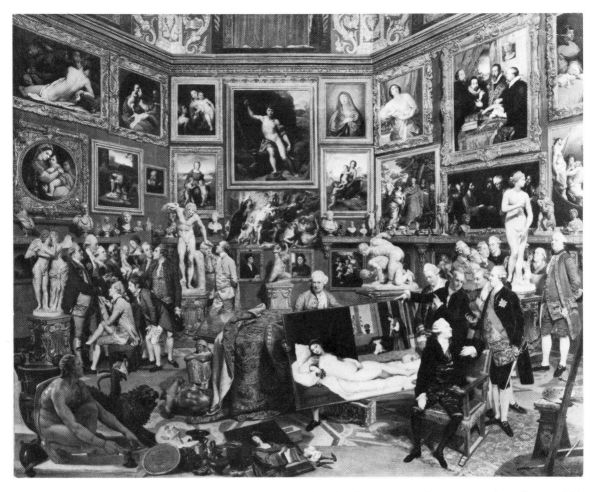

76 The Tribuna of the Uffizi 1772–7/8

Canvas, 123.5 × 155 (48⅝ × 61)

Provenance: painted for Queen Charlotte.
Exhibitions: R.A., 1780 (68); R.A., *Exhibition of the King's Pictures*, 1946–7 (48); R.A., *Italian Art and Britain*, 1960 (125); The Queen's Gallery, *George III Collector and Patron*, 1974–5 (47).
Literature: O. Millar, *Zoffany and his Tribuna*, 1966 (essential for detailed study of the picture); O. Millar, *Later Georgian Pictures in the Collection of Her Majesty The Queen*, 1969, no. 1211; *Mostra Storica della Tribuna degli Uffizi*, Quaderni degli Uffizi, I, Florence, 1970–1.

The Tribuna, the most famous room of the most famous gallery in Europe, was built in 1585–9 by Buontalenti for Francesco de' Medici to house the finest and most precious works of art in the Medici Gallery. In the eighteenth century it still fulfilled its original role in the arrangement of the gallery, and much of the original decoration survived in Zoffany's

day. In the summer of 1772, after the collapse of his plans to go with Sir Joseph Banks on Cook's second expedition to the South Seas, Zoffany went to Italy to paint for Queen Charlotte a view of 'the Florence Gallery'. For this commission he was accorded special facilities and privileges by the Grand Duke of Tuscany. He began work on the picture shortly after his arrival in Florence in August 1772, finishing much of it by the end of 1773, but continuing to add to it at least until December 1777. He only finally left Florence in April of the following year.

The arrangement of the pictures hanging on the walls and of the statues differs considerably from their actual disposition in the Tribuna of the 1770s. This is because the picture is as much a selective portrait of the Grand-Ducal collection as of the Tribuna, which Zoffany has chosen as his setting because of the especial fame of the treasures it housed. Indeed Zoffany 'had leave to have any picture in the Gallery or Palace taken down [and] transported . . . into his Tribune'; thus as many as seven pictures were brought from the Pitti. The objects on the

shelves have been rearranged and those on the floor have perhaps been added, not only to give a richer impression of the Grand-Ducal collections but to avoid the great difficulties in painting the complicated pattern of the marble floor in correct perspective. In May 1790 the Princess Royal wrote to her brother Augustus, then on his travels abroad: 'I hope that you will not be angry when I tell you that I rather envied your having the pleasure of seeing so many fine Pictures [in] the Gallery of Florence which is acknowledged to be superior to any thing of the kind from the variety of fine things executed by the first Masters in the World which it contains. If you recollect the Picture that Zoffany painted of the Tribune I beg that you will let me know whether you think it like, for the sake of representing them he has brought some pieces into that room which do not belong to it but as they are either held up by some body to be seen or are standing on the Ground this objection does not I suppose take off from its likeness to the Room if in other particulars he has followed the original close'. (Windsor, Royal Archive, Georgian Add. 9, 88, kindly communicated by Sir Oliver Millar.)

'Small figures as Spectators', following the long established tradition of pictures of galleries and collections, had been part of the original scheme for the composition. Zoffany's eager groups of English travellers who had visited the gallery were however a lively innovation of the artist's, and one for which he was much criticised by his royal patrons and by contemporaries. They are nevertheless a brilliant solution to the problem of enlivening and ordering a composition crowded with inanimate objects. The group at the right admiring Titian's *Venus of Urbino* includes Sir Horace Mann, British Envoy Extraordinary at the Court of the Grand Duke, wearing the ribbon and star of the Order of Bath, the Hon Felton Hervey, Groom of the Bedchamber to the Duke of Cumberland, turning round in his chair, and the painter Thomas Patch. At the far right, wearing red, is the famous African traveller James Bruce. On the left Lord Cowper (see no. 77) stands pointing to the Niccolini-Cowper *Madonna* by Raphael which is held up by Zoffany himself. Zoffany had acquired this picture in Florence and sold it to Lord Cowper. It was one of the two Raphaels belonging to Cowper which Zoffany was to attempt to sell on his behalf to George III in 1780–1.

'A most perfect idea of the magnificent interior of the Medicean gallery is given in that singular effort of genius by Zoffani', wrote that man of taste, the Reverend James Dallaway in 1800 (*Anecdotes of the Arts*, p. 89). *The Tribuna* is a painting of inimitable verve, executed with consummate patience and skill. Technically it is a tour-de-force, with its accurate imitation of the manner of the different painters whose pictures are copied, of the surfaces of pottery, bronze, marble and other stones, and of the textures of carpets and hangings. In this picture, still so crisp and fresh, the artist has fixed a lasting image of eighteenth-

century taste and connoisseurship. He has also perfectly fulfilled his commission to concentrate in a single composition the greatest treasures of the Grand-Ducal gallery, which Queen Charlotte and King George could never hope to see themselves, but which for eighteenth-century travellers was the culminating artistic experience of a Grand Tour.

Her Majesty Queen Elizabeth II

77 George Nassau, 3rd Earl Cowper *c.* 1773

Canvas, 142.2 × 111 (56 × 43¾)

Provenance: by descent.
Exhibition: R.A., *European Masters of the Eighteenth Century*, 1954–5 (97).
Literature: M. L. Boyle, *Biographical Catalogue of the Portraits at Panshanger*, 1885, p. 404; D. Sutton, 'Paintings at Firle Place', *The Connoisseur*, CXXXVII, 1956, suppl. pp. 79–84.

George Nassau, 3rd Earl Cowper (1738–89), who inherited a large fortune at the age of sixteen, first visited Italy in 1759 on the Grand Tour. He was MP for Hertford 1759–61, sitting in the Whig interest. Thereafter, preferring to live away from what he called 'the dull melancholy of England', he returned to Florence where he played a very active part in Florentine society. He was renowned for his lavish hospitality which included elaborate musical entertainments given at the Villa Palmieri on the slopes of Fiesole. He made an important collection of pictures by Renaissance and seventeenth-century masters, and

patronised contemporary artists. He maintained an interesting correspondence with Alessandro Volta and set up a suite of five rooms in his house for scientific experiments. He became a Fellow of the Royal Society.

Not long after the failure of protracted marriage negotiations with a Florentine lady, he announced his betrothal to Miss Anne Gore (see nos. 78 and 79), whom he married in 1775. Created a Prince of the Holy Roman Empire in 1778, Lord Cowper took his many honours too seriously and was in consequence much ridiculed.

Lord Cowper enjoyed favour at the Grand-Ducal court and used his influence with Pietro Leopoldo (no. 82) on behalf of English artists who wished to copy in the Gallery. It is not surprising that the first intimation of Zoffany's visit to Florence should be in a letter addressed to Lord Cowper by Lady Spencer on 23 June 1772: 'I have the Queens Commands to recommend Zoffani a painter and a very ingenious man to your Lordships protection, Her Majesty sends him to Florence & wishes to have him admitted into the Great Dukes Gallery this I have no doubt will be a sufficient Motive for your Lordships gaining him every advantage in your power, but I cannot in justice to the Man help adding that he has uncommon Merit and has distinguish'd himself very much in his stile of Portrait Painting'. (O. Millar, *Zoffany and his Tribuna*, 1966, p. 10.)

Lord Cowper decided to act on this recommendation himself, possibly soon after Zoffany's arrival. He is portrayed standing on a hillside above Florence, perhaps intended to represent the grounds of his villa at Fiesole, his left hand resting on a cane, his right raising a gold-braided hat above his head. The meaning of this gesture has not been explained. The cut of his waistcoat and the sword indicate that he may be wearing a uniform; if so it is likely to be court dress as worn at the Grand-Ducal court. The hat he holds is similar to the one lying on the chair in Zoffany's portrait of the Archduke Francis (no. 80), while the edging material, the skirts and flap pockets of his waistcoat resemble those shown on Batoni's portrait of Pietro Leopoldo with his brother the Emperor Joseph II (Kunsthistorisches Museum, Vienna).

Viscount Gage

78 Miss Anne Gore as a Savoyarde 1774

Canvas, 122 × 97.8 (48 × 38¾)

Provenance: by descent.
Exhibition: Arts Council, *Johann Zoffany*, 1960 (14).
Literature: D. Sutton, 'Paintings at Firle Place', *The Connoisseur*, CXXXVII, 1956, suppl. pp. 80–1.

Hannah Anne Gore (c. 1758–1826), youngest daughter of Charles Gore of Horkstow, Lincolnshire, as a Savoyarde holding a hurdy-gurdy. Horace Mann, British Envoy at Florence, reported on 13 September 1774: 'Lord Cowper has declared his intention of marrying the youngest daughter of Mr. Gore, a gentleman of Lincolnshire, who with his wife and two other daughters has been here some months. The young lady is not quite sixteen years of age, the marriage therefore will not be celebrated till this time twelvemonth'. (*Horace Walpole's Correspondence with Sir Horace Mann*, ed. W. S. Lewis, VIII, 1967, p. 38, n. 6.) Her marriage to George, 3rd Earl Cowper (no. 77), took place in Florence on 2 June 1775.

In high favour at the Grand-Ducal court, Lord and Lady Cowper enjoyed a splendid position in Florentine society. Mary Berry (no. 70) who visited them in 1784 recorded that at their house 'you have the best of society, both native and foreign, and where all the English (in particular) are desirous of obtaining an introduction'. (*Extracts from the Journal and Correspondence of Miss Berry*, ed. Lady Theresa Lewis, I, 1866, p. 14.) Lady Cowper, who long outlived her husband, had a faithful admirer in Robert Merry, one of the Della Cruscan poets.

Painted before their marriage, this portrait is probably the original of a water-colour referred to by Mrs Delany on 21 February 1775 when she writes about a conversation with Lady Cowper, the 3rd Earl's stepmother, saying that 'she was full of . . . her commissions from Lord Cowper for jewells for his lady elect, whose picture in water-colours he has sent her (like a Savoyarde,) pretty eno' tho' not answering her character for beauty, but I suppose it does not do her justice'. (*The Autobiography and Correspondence of Mary Granville, Mrs Delany*, 2nd ser., II, 1862, p. 111.) The conceit of the costume of a Savoyarde peasant, a scarf loosely tied over her hair, and the pose, turning the handle of a hurdy-gurdy, are intended to suggest a pastoral simplicity and innocence.

Viscount Gage

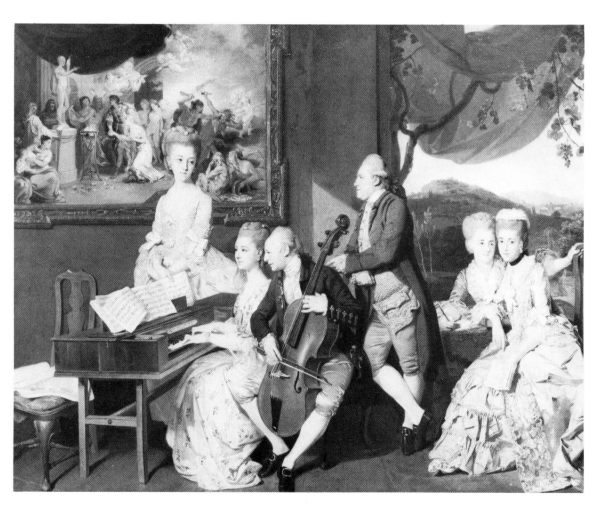

79 Lord Cowper and the Gore family 1775

Canvas, 75 × 94 (29½ × 37)

Provenance: painted for the 3rd Earl Cowper, lost after the death of his wife in 1826, discovered in an antique shop in Florence in 1845 and purchased by the Hon Charles Spencer Cowper, who gave it to his brother, the 6th Earl Cowper; by descent.
Exhibitions: Conversation Pieces, 1930 (26); R.A., *British Art*, 1934 (306); R.A., *European Masters of the Eighteenth Century*, 1954–5 (122).
Literature: M. L. Boyle, *Biographical Catalogue of the Portraits at Panshanger*, 1885, pp. 308–9.

On an open terrace with a view of Tuscany in the background, Mrs Gore, holding a book, is seated beside one of her three daughters. Her husband, Charles Gore of Horkstow, Lincolnshire, is playing the violoncello to the accompaniment of his daughter Emily on the square piano. Standing in the middle of the group is George, 3rd Earl Cowper (no. 77), and in front of the picture which hangs on the wall is Hannah Anne (no. 78), youngest daughter of Mr and Mrs Gore, who married Lord Cowper on 2 June 1775.

This conversation group must have been painted about the time of the marriage to which the picture on the wall clearly alludes in the form of an allegory in an antique setting. A marriage is being celebrated in the

Temple of Hymen: on the left is the altar of the god with priests in attendance, before it are a smoking incense burner and a musician playing the lyre. A handsome youth holds the right hand of his modestly kneeling bride; behind are her attendants, the Three Graces. Above is Iris, the messenger of the gods, followed by Cupids. On the right the youthful Hercules, whom Iris has summoned, seizes the hair of Calumny, now unmasked by two Cupids. The River God and nymph in the bottom right corner represent the Arno. The obvious explanation of this scene is that unkind gossip had been successfully repelled. It is interesting that Zoffany should have introduced an exercise in German baroque allegory into a very English conversation piece.

Thomas Agnew & Sons Ltd

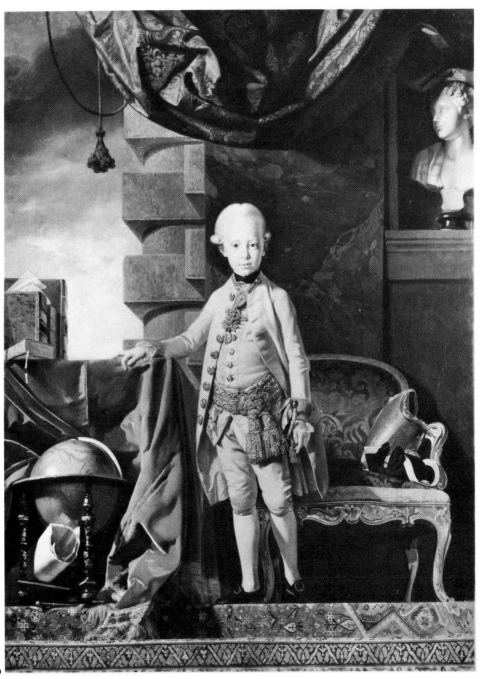

80

80 The Archduke Francis 1775

Canvas, 198×145 (78×57⅛)

Provenance: perhaps painted for presentation to Maria Theresa.
Literature: M. Zweig, 'Royal Portraits by Zoffany in Vienna', *The Connoisseur*, CIV, 1939, pp. 80–1.

The eldest son of Pietro Leopoldo, Grand Duke of Tuscany, (no. 82) and his wife Maria Louisa, Francis (February 1768–1835) succeeded his father and was crowned Emperor of the Holy Roman Empire as Francis II in 1792. In 1806 he renounced this title and became Francis I, the first Emperor of Austria. His reign was overshadowed by the French Revolution and the Napoleonic Wars. His daughter Marie Louise married Napoleon in 1810.

Portrayed here at the age of seven years, the Archduke Francis wears the Golden Fleece with which he was invested at the age of one month and thus acknowledged as heir to the house of Austria. He stands on a carpeted ledge, in front of a dark grey marble and stone pillar. The books, globe and bust, thought to be of Marcus Aurelius (now called 'Annius Verus', O. Millar, *Zoffany and his Tribuna*, 1966, key to contents of the Tribuna, no. 72), are an allusion to the Archduke's education, the breastplate on the chair behind his hat to his future military prowess.

Zoffany's first commission from the Grand-Ducal family, this portrait was begun in Palazzo Pitti at the end of 1774. On 29 December a breastplate and a whole suit of armour from the Armoury, and a small marble bust of Marcus Aurelius from the Tribuna, were taken there for Zoffany's use in his composition. These objects were returned on 9 March 1775 (Uffizi, Filza VII, 1774 (48)).

In placing the figure slightly behind the ledge, and in the use of a curtain to fill the upper part of his canvas, Zoffany has repeated the compositional device used in his portrait of Charlotte, Princess Royal, and Prince William (no. 62). This portrait of the Archduke Francis may also have been intended to be seen from below.

Kunsthistorisches Museum, Vienna

81 The Archduchess Maria Christina 1776

Canvas, 131.5×96.5 (51¾×38)

Provenance: painted for Maria Theresa.
Exhibition: Angelika Kauffmann und ihre Zeitgenossen, Bregenz and Vienna, 1968 (493).
Literature: Kunsthistorische Sammlungen des Allerhöchsten Kaiserhauses, die Gemälde-Galerie, Vienna, 1896, p. 462, no. 1590; M. Zweig, 'Royal Portraits by Zoffany in Vienna', *The Connoisseur*, CIV, 1939, pp. 81–2.

The Archduchess Maria Christina (1742–98), favourite daughter of the Empress Maria Theresa. A Tuscan landscape in the background, the Archduchess is seated with her arm resting on a marble-topped gilt table on which stands, as an allusion to the Arts, a statuette of Athena. She holds a small brown Bolognese lap-dog. The miniature on the bracelet worn on her right wrist is of her husband Prince Albert of Saxony, Duke of Saxe-Teschen, whom she married in 1766. With her husband she was appointed conjoint governor of the Austrian Netherlands from 1781. Prince Albert is now remembered as the founder of the great collection of drawings in Vienna, known as the Albertina. He commissioned Canova to execute the splendid monument to the Archduchess Maria Christina in the Augustinerkirche, Vienna (see Arts Council, *The Age of Neo-Classicism*, 1972 (310–13)).

The Archduchess and her husband were in Florence as guests of her brother the Grand Duke from 11 January to 22 February 1776 at Palazzo Pitti, and for four weeks in May and June at Poggio a Caiano. (A. Wandruszka, *Pietro Leopoldo*, Florence, 1968, p. 330.) The journey was undertaken for pleasure and on the instructions of the Empress the Archduchess sat to Zoffany for her portrait. (*Maria Theresia und Joseph II ihre Correspondenz*, ed. A. Ritter Von Arneth, II, Vienna 1867, pp. 92–4; *Briefe der Kaiserin Maria Theresia an ihre Kinder und Freunde*, ed. A. Ritter von Arneth, II, Vienna, 1881, p. 402.)

The young and gay Maria Hadfield, who was hoping for a ball in Palazzo Vecchio to celebrate the visit, wrote on 24 February 1776 to her friend Ozias Humphry with the news that Zoffany had begun the portrait of the Archduchess. (R.A., *Ozias Humphry Correspondence* II, 40, 42.)

In this highly finished portrait Zoffany has achieved a most judicious combination of formality and naturalism.

Kunsthistorisches Museum, Vienna

82 Pietro Leopoldo, Grand Duke of Tuscany
(1776)

Line and stipple engraving by Jacob Adam, Vienna, 1784
16×9.3 $(6\frac{1}{4} \times 3\frac{5}{8})$

Third son of Maria Theresa and Francis Duke of Lorraine, the Archduke Peter Leopold (1747–92) married Maria Luisa, daughter of Charles III of Spain, in August 1765. On the death of his father two weeks later he succeeded to the Grand Duchy of Tuscany. He went at once to Florence where he energetically pursued the changes begun under the Regency, and devoted his reign to working out reforms in minute detail. He succeeded his brother Joseph II as the Emperor Leopold II in 1790.

Zoffany was commissioned by Joseph II (Farington Diary, 31 March 1797) to paint a life-size group portrait of Pietro Leopoldo, as he was known in Florence, and his family in 1775. (Vienna, Haus und Staatsarchiv, F. A. Sammelbände 7, 1775, f. 73v–73.) Zoffany took the picture to Vienna where he was created a Baron of the Holy Roman Empire by Maria Theresa on 4 December 1776. (O. Millar, *Zoffany and his Tribuna*, 1966, p. 39.)

Engraved from a detail of the group portrait now in the Kunsthistorisches Museum, Vienna (fig. 1).

Her Majesty Queen Elizabeth II

83 Miss Matilda Clevland 1777

Canvas, 57×44 $(22\frac{1}{2} \times 17\frac{1}{4})$

Literature: O. Millar, *Zoffany and his Tribuna*, 1966, pp. 25–6.

Matilda-Shore, daughter of John Clevland, MP for Saltash and secretary to the Admiralty, by his second wife Sarah Shuckburgh. Painted while travelling in Italy with her sister Selina, their cousin, a young Swiss nobleman named Louis-François, Baron Guiger de Pragens, who later became Matilda's husband, and the Baron's aunt. On arrival in Florence in April 1777 they went to the Gallery to seek out Zoffany, whom they knew already, and agreed that Selina would employ him to paint the portrait of her sister. The Baron's Journal records sittings on 16, 17, 18, 22, 23, 28 April and 3 May; on 17 April he wrote: 'Le portrait sera charmant, et cette forme est mille fois plus agréable que le miniature sur une boite, ou la tête seule de grandeur naturelle. La figure sera entière, environ 15 pouces d'hauteur, assise sous des arbres, et une vue de Toscane dans l'eloignement'. Selina Clevland married John Udney, the famous collector and English consul at Leghorn.

From the Baron's description, which he quotes for the first time, Oliver Millar (*op. cit.*) was able to identify the sitter of this charming small portrait.

Private collection, USA

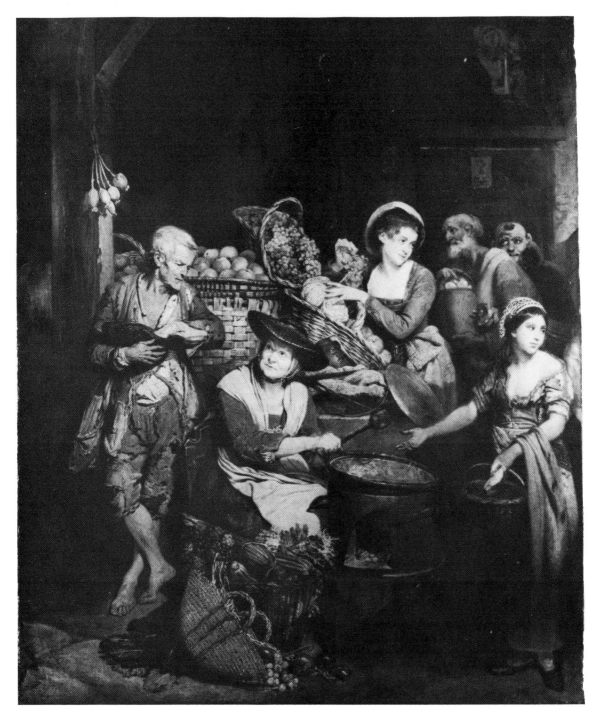

84 A Florentine Fruit Stall *c.* 1777

Canvas, 58×49 (22¾×19⅜) (cut down on the right)

Provenance: probably Zoffany's studio sale, Robins
9 May 1811 (90); Sir William Proctor; Mrs Beverley
before 1913, by descent, Christie's 12 June 1931 (47)
as Henry Walton; Ernest Cook, bequeathed through
the NA-CF 1955.

If this is the picture described in Zoffany's sale
catalogue as 'a most excellent groupe, very highly
finished and one of his best performances', Zoffany
may perhaps have painted it for his own pleasure,
since he kept it until his death.

The four main figures, an old beggar, a market-
woman and her daughter, and a girl, perhaps a
contadina, with a basket, give the appearance of being

portraits from living models. The gestures of the young girl and the woman holding a bunch of grapes and a basket of fruit as though inviting a purchaser to buy suggest that the picture has been cut down on the right, perhaps by as much as 25.4 centimetres (10 inches), which would leave room for two additional figures. Cleaning in 1962 revealed a fragment of a figure to the right of the girl's shoulder. In the background is a Capuchin friar treated with the humorous cynicism customary in the eighteenth century towards this particular order.

Zoffany's keen interest in still-life and everyday scenes is reflected in this composition, which may have inspired Mrs Piozzi to remark when visiting the market place at Alexandria: 'and who could help longing then for Zoffany's pencil to paint the lively scene'. (*Glimpses of Italian Society* (1784), 1892 ed. p. 53.)

Probably painted in the autumn of 1777 when Zoffany's commissions to the Grand-Ducal family were finished and the last touches were being put to *The Tribuna* (no. 76) before he left Florence in the spring of the following year.

(I am indebted to Mr Martin Butlin for kindly allowing me to make use of material in the Gallery archives.)

The Trustees of the Tate Gallery

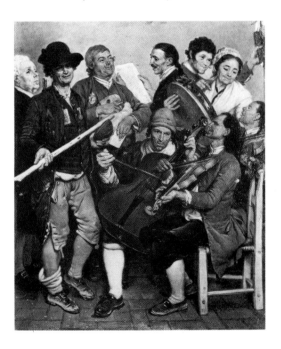

85 The festival of the maize harvest, 'La Scartocchiata' 1778

Panel, 46×37 ($18\frac{1}{8} \times 14\frac{1}{2}$)

Provenance: collection of the Dukes of Parma, given by Maria Luigia to the Gallery 1821, taken back 1851, reinstated 1865.

Literature: P. Toschi, *Notizie delle pitture e statue della Pinacoteca di Parma*, 1825, p. 25; *Nota dei quadri retroceduti al Guardamobile ducale*, 1851, p. 208; *Nota della suppellettile artistica retroceduta dall' Academia di Parma*, 1865; A. Ghidiglia Quintavalle, 'Il pittore Johann Zoffany alla corte di Don Ferdinando', *Aurea Parma*, XXXIX, 1955, p. 8, no. 11; G. Cusatelli, A. Bertolucci, *Dai ponti di Parma*, Bologna, 1965, p. 199.

A festival celebrating the maize harvest, *La Scartocchiata*, on the land of the court architect Ennemond Alexandre Petitot (1727–1801), perhaps at Marore, a house he built for himself a few miles out of Parma. Petitot is the figure at the extreme left, wearing a wig and holding a gold-headed cane.

Formerly an enigma and wrongly entitled 'A Concert of Ambulant Musicians', the subject of this famous small picture can be identified from Moreau de Saint-Méry, *Description topographique et statistique des Etats de Parme* (Parma, Archivio di Stato, Carte Moreau I, i, pp. 293–301), to which it corresponds exactly. In this survey of the Duchy of Parma, made at the end of the eighteenth century, Moreau wrote: 'The sole occasion on which the wretched inhabitants of the countryside forget the misery of their condition is the maize harvest in the states of Parma.

The task of stripping the ears is an occasion of pleasure for the peasants, and this operation is called La Scartocchiata [from *scartocchiare* – to strip, discard].

The proprietor has gone round to invite his neighbours to come and share in this task. This slight service is never refused, because everyone receives it in his turn, and because it is occasion for a festival which gives pleasure to all.

It commonly takes place in the evening, so that between the end of the day's work and the meeting at the rendezvous, there is time for the peasant men and women to dress up.

It is impossible to work more gaily . . . all the workers sit in a circle round a pile of cobs and encourage each other in the work.

At about eleven o'clock or midnight the proprietor stops the work, and great plates of soup made with a thick paste are brought for the workers, with bread and several jugs of the best wine of the country, and the crumbs of this frugal repast soon disappear.

Suddenly the sound of several instruments is heard. The master of the house has summoned one or two violins for this festival, given exclusively for the peasants. They are indeed so jealous of it that they collect among themselves and give to the proprietor what they consider a payment for the music, so that they have the right to dance as much and as long as they please. In order not to displease them this contribution must be accepted.

If violins are lacking, the musette, that ancient and faithful companion of the inhabitants of the countryside, takes their place with its monotonous and strident sounds, and in their pleasure the peasants appreciate it just as much as the most harmonious orchestra

La Scartocchiata is the occasion for the reunion of

the friends of the proprietor, who amuse themselves by watching the gaiety of the peasants which they encourage by their applause . . .'.

In the picture we see a peasant on the left with a stick and a bowl for the contributions to the musicians. He wears two badges, probably of a confraternity. The man standing to the right of him holds the musette – the bellows-blown bagpipe; in the centre is a 'cellist and to the right two violins. The peasant woman holds a tambourine, while a young man behind her holds up the stripped maize cobs which are the occasion of the festival. In the centre at the back a better dressed man, holding a piece of paper, is probably Petitot's *fattore* (bailiff).

This ranks as one of Zoffany's most skilfully composed and liveliest pictures.

(Signora Marcello Boni most kindly showed me Petitot's house at Marore.)

Galleria di Parma

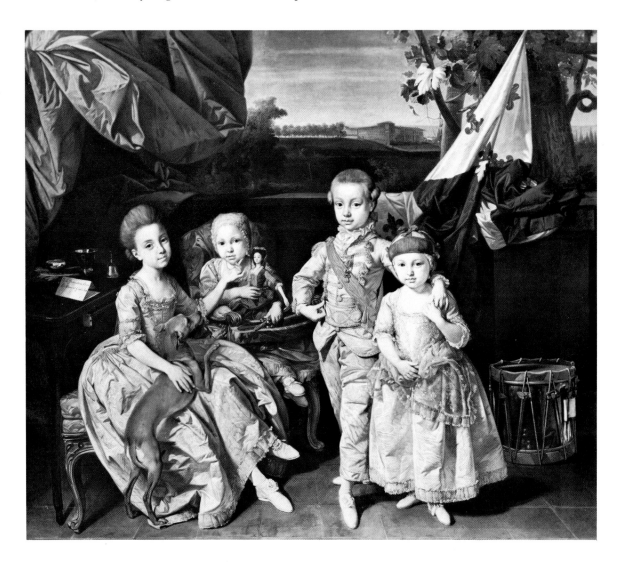

86 Four grandchildren of Maria Theresa 1778

Canvas, 159 × 185 (62⅝ × 72⅞)
Inscribed on the folded letter on the table:
A L'Imperatrice Reine Ma Dame, et Grand Mere

Provenance: painted for presentation to Maria Theresa.
Literature: Kunsthistorische Sammlungen der Allerhöchsten Kaiserhauses, die Gemälde-Galerie, Vienna 1896, p. 462, no. 1591; M. Zweig, 'Royal Portraits by Zoffany in Vienna', *The Connoisseur*, CIV, 1939, pp. 82–3.

The four eldest children of the Archduchess Maria Amalia, daughter of Maria Theresa, and her husband Duke Ferdinand of Parma. Their marriage in 1769 was a political blunder and the tragi-comic activities of the turbulent Archduchess rendered the court of Bourbon

Parma a byword. However, prestige was somewhat restored by the birth of her son Louis (July 1773–1803), King of Etruria in 1801, portrayed here standing on a terrace with his three sisters. On the left sits the eldest daughter, Carolina Maria Theresa (November 1770–1804), firmly holding down a brown courser which has jumped on her knee and raises a playful paw towards Charlotte Maria (September 1777–1825), seated in a child's chair holding a coral rattle and an elegantly dressed doll. Next is Louis wearing the Order of the Golden Fleece with his arm on the shoulder of his sister Maria Antonia (November 1774–1841). Over her cap she wears the equivalent of an English child's 'pudding' – 'a broad silk band padded with wadding which went round the middle of the head, joined to two pieces of ribband crossing on the top of the head and then tied under the chin; so that by this most excellent contrivance, children's heads were often preserved uninjured when they fell'. (J. T. Smith, *Nollekens and his Times*, I, 1920, pp. 196–7.)

The blue and white flag of Bourbon Parma is draped by a vine on the right and in the background Zoffany has shown the royal palace in Parma. On the writing-table at the left are silver writing implements and a letter addressed to Maria Theresa, indicating that this picture was a gift to the Empress.

After leaving Florence at the end of April 1778, Zoffany worked at the Court of Parma, and remained in the city some twelve months. The ages of the children indicate that the group was painted in the late summer of 1778. A miniature copy of the picture, painted by Franz Walter in 1779 (Hofburg, Vienna, *Verzeichnis fremder Bilder* no. 726), includes a vase on a pedestal to the right, the whole of the writing-table and a doorway flanked by columns to the left, which may suggest that the picture has been cut down.

Kunsthistorisches Museum, Vienna

England 1779-1783

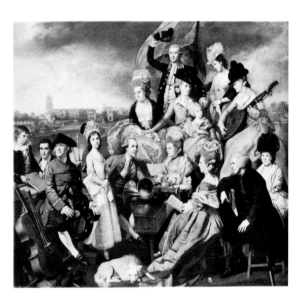

87 The Sharp family 1779–81

Canvas, 115.5×125.7 ($45\frac{1}{2} \times 49\frac{1}{2}$)

Provenance: painted for William Sharp, by descent.
Exhibitions: R.A., 1781 (85); R.A., *British Art*, 1934 (295); R.A., *European Masters of the Eighteenth Century*, 1954–5 (120); Arts Council, *Johann Zoffany*, 1960 (13); R.A., *Bicentenary Exhibition 1768–1968*, 1968–9 (62).

The musical sons and daughters of Thomas Sharp, Archdeacon of Northumberland, formed a united family group who gathered regularly, giving fortnightly concerts on Sundays from the 1750s onwards. The Sharp orchestra reached the height of its fame with water concerts, commemorated in this family conversation piece on board their sailing barge *The Apollo*, at Fulham.

Painted for William Sharp (1729–1820), surgeon to George III, who stands wearing Windsor uniform at the stern of the boat, holding the tiller in one hand and raising his hat with the other. Seated below him with their daughter Mary (b. 1778), who holds a kitten, is his wife, her hand clasping that of her sister-in-law, Mrs James Sharp. At the far left are a cabin boy and the boat-master, in front of whom sits James Sharp holding a serpent; beside him stands his daughter Catherine and to her right is Granville Sharp, philanthropist and abolitionist. Seated at the harpsichord is his sister Mrs Elizabeth Prowse, who recorded in her diary: '*1779* Nov 12 Sifr: F and the children left me, as all the party was siting to Zopheney for the Family Picture, and when I go to Town am to be added to the party.

Nov. 29. Sifr. Jud and I set out for London and my picture was aded to the Grupe.

1780 Dec: Near Xmass Zopheney came to finish my picture and Bro: G[ranville] came down with him in order to have it finished for the Expition in the Spring. . .' (See no. 88.)

Her sister Frances sits at the front holding a sheet of music, her brother John Sharp, Archdeacon of Northumberland, resting his arm on the back of her chair; above them their sister Judith sits holding a theorbo. In the foreground is Zoffany's dog, Roma.

Each member of the family played his own instrument – James the serpent, Granville performed on two flutes, Archdeacon John the 'cello and William the French horn. The two French horns lying conspicuously on the harpsichord make a visual compliment to the musicianship of the brother for whom the picture was painted.

Perhaps Zoffany's most masterly arrangement of many figures as a single group. The skill with which the serpentine line and pyramidal climax are employed to order the composition should be noted, as well as the artful use of a variety of facial views to animate the ensemble.

The Executors of the late Miss O. K. Ll. Lloyd-Baker

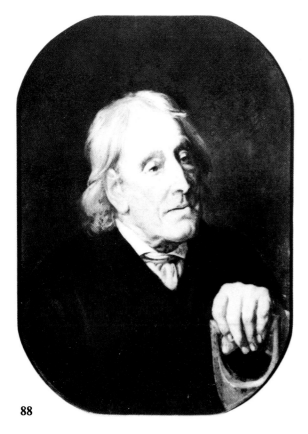

88

88 Jonathan Jackman 1780

Panel, 62.2 × 49.5 ($24\frac{1}{2}$ × $19\frac{1}{2}$)
Inscribed on the reverse: *Jonathan Jackman. 60 years gardener at Wicken Park. He sat for Mr. Zoffany for his picture the day he completed his 80th year. He died April 29th 1783, aged 82.*

Provenance: W. Murray-Browne (1960).
Exhibition: Arts Council, *Johann Zoffany*, 1960 (not in catalogue).

Shortly after his return from Italy in the second half of 1779 Zoffany began the conversation piece of the Sharp family (no. 87). Mrs Elizabeth Prowse (née Sharp), who is the lady seated at the harpsichord in that group, records in her diary the story of her gardener's portrait: '*1780* Dec: Near Xmass Zopheney came to finish my picture and Bro: G came down with him in order to have it finished for the Expition in the Spring, but by some mistake it did not arrive by 2 days, at the time expected, but he finished my picture and one of Old Jonathan, my Gardner, which the weather being bad no temptation to go out, he desired to take, and for want of proper materials, did it upon an old Mahoganey Drawing Board, for drawing upon and could he have had time to have finished it, believed it would have been one of his best pictures, and would have been glad to have had him come up to Town to have finished it. He was compleatley 80 on one of the days he sat, but such a journey might have nocked him up. I could not consent to it. He sayd he had worked 60 years in this garden. He lived 2 years more in the Garden and the last 10 days unable to come up'. (Kindly communicated by Mrs Cobham.)

Mrs R. H. Cobham

89 The Watercress Girl (1780)

Mezzotint by John Raphael Smith, 1780
38 × 27.6 (15 × $10\frac{7}{8}$)

Literature: C.S., p. 1320, no. 200.

On Zoffany's return from Italy in 1779 he found a new taste for fancy pictures coming into fashion. He produced at least two of these genre paintings of a sentimental, prettified realism (see also no. 90).

The picture from which this mezzotint was scraped (present whereabouts unknown) was exhibited at the Royal Academy in 1780 (204), when it was favourably received by the author of *A Candid Review of the Exhibition:* 'The Artist has been very fortunate in a choice of a most beautiful Girl for his subject and he has copied nature so exactly, that it is not easy to determine whether it is real life or a painting'. The sitter has been identified as Miss Jane Wallis.

Victoria and Albert Museum

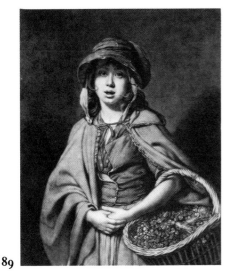

89

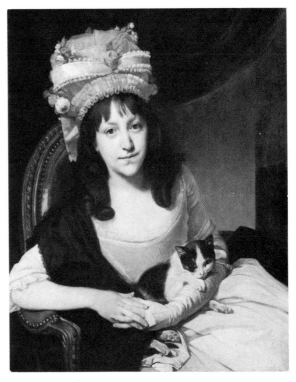

90 The Flower Girl (*c.* 1780)

Mezzotint by J. Young, 1785
38×27.6 ($15 \times 10\frac{7}{8}$)

Literature: C.S., p. 1646, no. 79.

A companion to *The Watercress Girl* (no. 89), presumably painted at about the same time. The original from which the mezzotint was scraped is untraced.

Victoria and Albert Museum

91 George Steevens (*c.* 1780)

Stipple engraving by W. Evans, 1800
15×11.5 ($5\frac{7}{8} \times 4\frac{1}{2}$)

George Steevens, FRS, FSA (1736–1800), the celebrated commentator on Shakespeare. The picture from which this engraving was made is untraced.

The Trustees of the British Museum

92 Thomas King in 'The Critic' (*c.* 1780)

Mezzotint by J. Young, published 1803
52.4×43.2 ($20\frac{5}{8} \times 17$)

Literature: C.S., p. 1636, no. 45.

Thomas King (1730–1805) as the original Puff in *The Critic* by Sheridan, first performed on 30 October 1779 at Drury Lane. Puff is shown making his final speech in Act I Scene ii, where he looks at his memoranda and tells Dangle about the schemes for newspaper puffs contained in them. King was a well-known actor and dramatist, with a dry, sarcastic humour; he was associated with Drury Lane for over forty years. The original composition must pre-date a small engraving of the head only, which was published in 1789.

National Portrait Gallery, London

93 Miss Sophia Dumergue *c.* 1780

Panel, 76.2×61 (30×24)

Provenance: by descent.

Sophia Dumergue (1768–1831), daughter of Charles Dumergue (*c.* 1739–1814), whom Zoffany appointed a trustee and executor of his will.

Charles Dumergue came to England as a surgeon in the suite of the French Ambassador, M de Flahaut, bringing with him his only daughter Sophia. He was one of the first to realise the importance to health of good dentistry. Having found favour at the English court he remained in practice in London, living in Bond Street, and became well known in the literary and scientific circles of Matthew Boulton, James Watt and later of Sir Walter Scott who often stayed with the Dumergues in London. His portrait by Zoffany has not been traced.

At the house to which the Dumergues moved in Piccadilly, visitors from France and refugees from the Revolution received much hospitality. Among them was a distant relation, Mlle Charpentier, who after a headlong wooing married Scott in 1797. Sophia Dumergue was entrusted with the purchase of clothes and other commissions in London for the wedding. She became godmother to the Scott's daughter, Charlotte Sophia, in 1799. (Carola Oman, *The Wizard of the North*, 1973, pp. 70, 74, 85, 362.)

Sophia, who never married, continued her father's hospitable tradition, holding salons where many eminent men and women gathered. After her father's death she presented to Queen Charlotte a cameo of his

bust set as a pendant with baroque pearls. (Private communication.)

Zoffany has portrayed Sophia at the age of about twelve wearing a very fashionable elaborate headdress.

Private collection

94 Miss Farren in 'The Winter's Tale' (*c.* 1780)

Mezzotint by E. Fisher, published 1781
60.3 × 40.5 (23¾ × 16)

Literature: C.S., p. 492, no. 17.

Elizabeth Farren, later Countess of Derby (1759–1829), as Hermione in *The Winter's Tale*, Act V. She is said to be portrayed as a statue, in the position she assumed on the stage. Delicacy was a characteristic of her acting.

The fine life-size portrait, clearly influenced by Reynolds, from which this mezzotint was scraped is now in the National Gallery of Victoria, Melbourne.

Victoria and Albert Museum

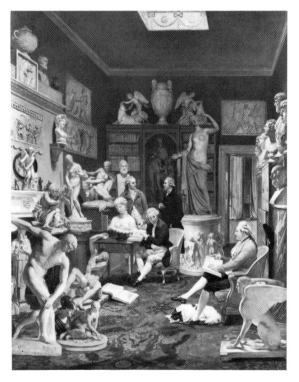

95 Charles Towneley's Library in Park Street 1781–3

Canvas, 127 × 99 (50 × 39)

Provenance: given by the artist to Charles Towneley, by descent to 3rd Lord O'Hagan, Christie's 19 May 1939 (92); purchased for Towneley Hall Art Gallery.
Engraving: line engraving by W. H. Worthington.

Exhibitions: R.A., 1790 (191); Arts Council, *The Age of Neo-Classicism*, 1972 (285).
Literature: M. Webster, *Burlington Magazine*, CVI, 1964, pp. 316–23.

This picture is one of the most celebrated of English conversation pieces. Charles Towneley (1737–1805) is seated among some of the finest marbles from his collection, the best and most famous English collection of classical sculptures of its day (see no. 139). His dog Kam lies at his feet. Seated facing him expounding his own original theories about Greek art is the French adventurer and antiquary Pierre Hugues, better known as d'Hancarville (?1729–1805), who was invited by Towneley to stay in his house in Park Street, Westminster, to catalogue the collection. Behind stands Charles Greville (1749–1809), Emma Hamilton's first protector, who points out some of the beauties of the bust of Clytie to the antiquary Thomas Astle (1735–1803).

It has long been recognised that this picture is our most evocative record of a circle of collectors whose enthusiasm for antique sculpture was one of the most significant expressions of early neo-classical taste in England.

The composition is another well authenticated instance of the freedom Zoffany gave himself to bring together the finest objects of a collection and arrange them effectively in a single setting. We know from contemporary evidence, visual and written, that the collection was very differently displayed in Park Street, and indeed no room in the house was large enough to contain so many sculptures together. J. T. Smith, who as a student had been employed by Towneley to make drawings for him, wrote of the picture that 'it was a portrait of the Library, though not strictly correct as to its contents, since all the best marbles displayed in various parts of the house were brought into the painting by the artist, who made it up into a picturesque composition according to his own taste'. (J. T. Smith, *Nollekens and his Times*, ed. W. Whitten, I, 1920, p. 213.)

Exactly dated in a letter written from Park Street by Towneley's sister to her brother on 16 September 1781: 'Zoffany has been here at yᵉ picture some days this last week, I wish much to see it finished' (private collection). Completed in 1783, the picture was not exhibited until 1790.

Zoffany made a present of it to his friend Towneley, at whose request he added the figure of the *Discobolus* in the left foreground in 1792.

Towneley Hall Art Gallery and Museums, Burnley Borough Council

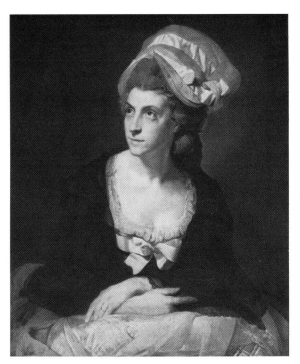

96 Mrs Zoffany *c.* 1781–2

Canvas, 75×61.5 (29½×24¼)

Provenance: by descent.

The artist's second wife Mary, née Thomas (*c.*1755–1832). Described by her friend Mrs Papendiek, to whom she related her life-story, as 'a perfect beauty, good-natured, kind and very charitable', Mrs Zoffany was of humble origin. Already pregnant, she secretly followed Zoffany to Italy in the summer of 1772, appearing before him during the journey; a son was born shortly after their arrival, and Zoffany is said to have married her there. In spite of her somewhat ambiguous position and lack of education, by rapidly acquiring polished manners and making quick progress in reading, writing and learning Italian, she gained not only acceptance, but favour in Anglo-Florentine society. Their son, placed under the care of the head nurse of the Grand-Ducal family, died after an accident at about sixteen months. Two daughters, Maria Theresa Louisa (*c.* 1776–1832) and Cecilia Clementina Elizabeth (*c.* 1778–?), were born while the Zoffanys were still in Italy. Two more daughters were born after Zoffany's return from India – Claudina Sophia Ann (1793–1869) and Laura Helen Constantia (1795–1876).

On returning from Italy Mrs Zoffany became closely acquainted with Mrs Papendiek, who is our source for almost all we know about her character and life. Although Mrs Papendiek's memoirs were written much later it is fair to assume that the general impression and many details concerning her 'dear friend' Mrs Zoffany are correct, though the remainder of the family felt they had been misrepresented and

certainly her account of them is unreliable. It is clear that Mrs Zoffany was of a charming and generous disposition; when the elderly sculptor Nollekens proposed to her about 1815 she declined, observing 'No, Sir, the world would then say, she has married him for his money', and after the sculptor's death, on learning that his servant had been left only nineteen guineas, she gave her a guinea long before receiving her own legacy.

Mrs Zoffany died of cholera on 30 March 1832, according to the inscription on the tomb in Kew churchyard, at the age of seventy-seven. (*Court and private life in the time of Queen Charlotte: being the journals of Mrs Papendiek, Assistant Keeper of the Wardrobe and Reader to Her Majesty*, ed. Mrs V. Delves-Broughton, I, 1887, pp. 85–9; J. T. Smith, *Nollekens and his Times*, ed. W. Whitten, I, 1920, p. 366; Manners & Williamson, pp. 131–6.

On grounds of style and costume this portrait can be dated *c.* 1781–2 when the Zoffanys had returned to England from Italy. Mrs Zoffany's dress, hair-style and cap are very similar to those of Mrs James Sharp (see no. 87).

Miss Claudine Beachcroft Roberts (direct descendant)

97 John Maddison *c.* 1782–3

Canvas, 126×100.5 (49⅝×39⅝)
Inscribed on bundle of papers held by the sitter: *To the Worshipfull/Company/of Goldsmiths*

Provenance: Richard Ovington; sale Robinson, Fisher and Harding 3 July 1919 (115), bt. John Lane, presented by Mrs Lane to the Brighton Art Gallery 1925.
Exhibitions: R.A., 1784 (2); Greenock, 1861 (38); Arts Council, *Johann Zoffany*, 1960 (8).

John Maddison (d. after February 1801) was a well-known broker of Charing Cross. He acted as Zoffany's stockbroker, stood security for him on his application to the East India Company for permission to go to India, and managed his financial affairs during the 1780s. Maddison was made free by redemption of the Goldsmiths' Company in 1763, and became a member of the Livery in 1767. He joined the Court of Assistants in 1771, attending for the last time in February 1801; he served as Warden of the Company 1780–3 and as Prime Warden 1784–5. After holding this office he visited India, returning to London in 1787. (Mrs Papendiek, *Court and private life in the time of Queen Charlotte*, I, 1887, p. 281.)

Portrayed wearing the black fur-trimmed robe of Warden of the Goldsmiths' Company, the sitter was identified by Horace Walpole when the picture was exhibited at the Royal Academy in 1784. It can be discerned in J. H. Ramberg's water-colour of the 1784 exhibition (British Museum). (I am indebted to Mr D. Beasley of the Goldsmiths' Company for biographical information.)

Royal Pavilion, Art Gallery and Museums, Brighton

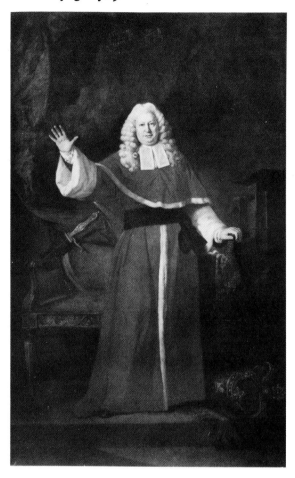

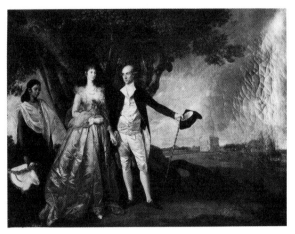

99 Mr and Mrs Warren Hastings 1783-7

Canvas, 119.5×90 ($47 \times 35\frac{1}{2}$)

Provenance: painted for Warren Hastings, by descent to Miss Marian Winter who bequeathed it to Lord Curzon, through whom acquired by the Victoria Memorial Hall.

Warren Hastings (1732–1818), Governor-General of Bengal, walking with his adored wife Marian (1747–1837) in the grounds of their house at Alipore, shown in the distance, accompanied by an ayah who carries her mistress's hat. In contrast with her husband's unostentatious dress, Mrs Hastings habitually wore an enormous quantity of jewels and she dressed according to her own taste, disregarding fashion. She was considered a 'great ornament of places of polite resort, . . . being a model of taste and magnificence . . . her appearance is rather eccentric, owing to the circumstance of her beautiful auburn hair being disposed in ringlets'. (H. E. Busteed, *Echoes from Old Calcutta*, Calcutta, 1888, pp. 140–1.)

The composition is the typical English eighteenth-century one for a portrait of a landed proprietor and his wife; the only truly exotic touches are the jack fruit tree and the Indian servant.

This picture is mentioned in the bill which Zoffany rendered to Hastings in February 1785 (see no. 104): 'A D°. [picture] of three small whole length figures of Mr and Mrs Hastings and Servant . . . sas [sicca rupees] 3,000'. As Mrs Hastings left Calcutta for England in January 1784 the picture was almost certainly begun before that date, though it was possibly not finished until 1787, for Nesbitt Thompson, attorney and private secretary to Hastings, wrote to him on 18 December of that year, 'I have not received the small full-length picture of yourself and Mrs Hastings'. (*Bengal Past and Present*, XVII, 1918, p. 120.)

Victoria Memorial Hall, Calcutta

98 Sir Elijah Impey (1783)

Platinotype, 52.4×32 ($20\frac{5}{8} \times 12\frac{5}{8}$)

Literature: W. Foster, *A descriptive catalogue of the paintings, statues, &c. in the India Office*, 1924, no. 262.

Sir Elijah Impey (1732–1809), Chief Justice of the Supreme Court of Judicature at Fort William in Bengal 1774–82, standing in judge's robes, his right arm upraised in the gesture of oration. A mace rests on the carpet at his feet, and a sword over the arm of the chair behind him.

One of Zoffany's first commissions on arrival in Calcutta was the imposing full-length life-size portrait painted for the High Court in the autumn of 1783, immediately before Impey's departure for England in December of that year. The portrait from which this platinotype was made hangs in the High Court at Calcutta.

India Office Library and Records

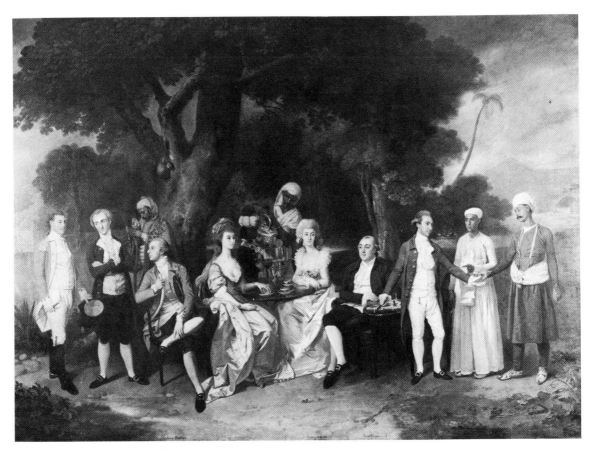

100 The Auriol and Dashwood families 1783–7

Canvas, 142 × 198 (56 × 78)
Inscribed in a later hand with the names of the sitters, see below.

Provenance: painted for James Peter Auriol, by descent.
Exhibitions: R.A., *Old Masters*, 1881 (41); *English Conversation Pieces*, 1930 (13).

The sitters in this family group, all linked by marriage, are, from left to right: Captain Charles Auriol, John Auriol, John Prinsep seated, Charlotte Auriol wife of Thomas Dashwood, Sophia Auriol wife of John Prinsep, Thomas Dashwood son of Sir James Dashwood of Kirtlington, seated at the chess table, and James Peter Auriol who has turned to receive a document from an orderly or messenger. Beside him stands a broker holding bills. In the centre two house servants are filling a teapot, and to the left a *hookah-burdar* is tending John Prinsep's water-pipe. Behind is a jack fruit tree.

This sumptuous picture would be indistinguishable from one of Zoffany's English conversation pieces were it not for the exoticism of the landscape and the presence of the Indian servants. Except for Captain Charles Auriol, who was in the King's Army, the men were all in the East India Company's service for at least part of their career in India. A senior merchant and agent for supplies, James Peter Auriol, for whom, according to family tradition, the picture was actually painted, was Secretary to the General Board at Calcutta and a protégé of Hastings.

The picture was probably commissioned to commemorate the departure of James Auriol who left India with his brother Captain Charles Auriol on the *Winterton* which sailed on 8 December 1783. He took with him to the Cape, which the ship reached on 3 March 1784, a letter for the Dutch Governor, Joakin van Plettenberg, and a ring inscribed 'ab hoste doceri' in recognition of the efforts made by the Dutch authorities to rescue the survivors of the wreck of the *Grosvenor* (*Bengal Past and Present*, XXVIII, 1924, pp. 219–20). The fact that the messenger hands Auriol a document, while Captain Charles Auriol is shown booted and spurred and holding a whip, lends strength to this interpretation of the picture and also explains why these two figures are placed at either end of the family group. The picture would therefore have been commissioned shortly after Zoffany's arrival in Calcutta in September 1783; it is likely that James and Charles Auriol sat for their portraits at this date, and that the other sitters were incorporated into the composition later. The sketchiness of Charles Auriol's portrait supports this view.

The picture cannot however have been finished

before 1787. The silver teapot, painted with Zoffany's accustomed accuracy, still exists and is hall-marked 1785; it could not have arrived in India before the end of that year, when Zoffany is known to have been at Lucknow. The picture must therefore have been finished in Calcutta, where the sitters resided, during Zoffany's stay there in 1787.

R. H. N. Dashwood, Esq

101 The Morse and Cator families *c.* 1784

Canvas, 110×99.5 (43¼×39¼)

Provenance: by descent to Hastings F. Middleton, Sotheby 18 June 1952 (46).

The sitters, identified by family tradition, are Robert Morse (d. 1816) playing the 'cello, with his sister Anne Francis (d. 1823), the wife of Nathaniel Middleton, former Resident at Lucknow. Beside her at the harpsichord, turning the page of the music book, is her sister Sarah, who gazes at her husband William Cator (d. 1800). Robert Morse was Advocate of the Supreme Court and Sheriff of Calcutta in 1783–4. William Cator, a factor in the service of the East India Company, made a collection of pictures while in India.

There is no indication in this composition that it was painted in India, though this was actually the case. The formal trappings of the setting – curtain, pillared architecture, vase – belong to the conventional repertoire of eighteenth-century portraiture, and the composition recalls that of the *Cowper and Gore families* (no. 79). The picture shows Anglo-India at its most self-consciously cultivated. Probably painted *c.* 1784. Finishing touches are lacking from the ladies' hands and arms.

Aberdeen Art Gallery

102 Asaf-ud-daula, Nawab Wazir of Oudh 1784

Canvas, 129.5×105.5 (51×41)
Inscribed on the reverse: *Joh. Zophany painted this Picture at Lucknow, A.D. 1784, by order of his Highness the Nabob Vizier Asoph Ul Dowlah, who gave it to his Servant Francis Baladon Thomas* (surgeon to the Lucknow Residency, dismissed 1784).

Provenance: purchased 1906.
Exhibitions: Whitechapel, 1908 (8); R.A., *The Art of India and Pakistan*, 1947–8 commem. cat. (914).
Literature: W. Foster, *A descriptive catalogue of the paintings, statues &c. in the India Office*, 1924, no. 106.

Asaf-ud-daula (d. 1797) succeeded his father Shuja-ud-daula as Nawab Wazir of Oudh in 1775. His reign was one of great extravagance and misgovernment and his court became a hunting-ground for many European adventurers. A contemporary wrote of him: 'He is mild in manners, generous to extravagance, affably polite and engaging in his conduct; but he has not great mental powers, though his heart is good. He is fond of lavishing his treasures on gardens, palaces, horses, elephants, and above all, on fine European gems, lustres, mirrors, and all sorts of European manufactures, more especially English, from a 2d. deal board painting of ducks and drakes, to the elegant paintings of a Lorraine or a Zoffani, and from a little dirty paper lantern to mirrors and lustres which cost up to £3,000 each'.

Claud Martin (see no. 105), who had cause to know him well, sent a vivid pen portrait to Ozias Humphry in March 1789: 'Colonel Mordaunt is now at the viziers Court, hunting, fighting Cocks and doing all he can to please the Nabob in expectation of being paid the large sums due to him by that Prince, but I fear much of his success, as the Vizier is not much willing to pay his debt particularly to Europeans for what I know of his character I think it such that if one could read in his heart he would perceive it loaded with many dark and sinister intentions, and as you know those who compose his court you then ought to know what man he is. A man that delight in Elephant and Cocks fighting would delight in something worse if he feared nothing'.

When Zoffany returned to Lucknow in March or April 1785 it may have been at the bidding of Asaf-ud-daula, for Martin's letter continues: 'this Good man is not yet paid tho' he was called by the Vizier and abandoned his own business at Calcutta in the hope of doing better, and to this day he has not received a farthing from Vizier, Minister or any of the blacks'. (R.A., *Ozias Humphry Correspondence*, IV, 24.)

Asaf-ud-daula, who wears a bejewelled Lucknow turban, is shown seated in a typical Indian posture leaning on cushions. Of the many portraits of the Nawab that Zoffany is known to have painted (see no. 124) this is the only example that has been traced.

India Office Library and Records

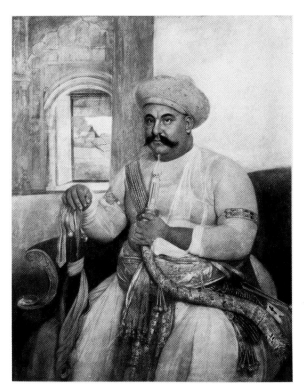

103 Hasan Reza Khan 1784

Canvas, 129.5 × 105.5 (51 × 41)
Inscribed on the reverse: *Joh. Zophany painted this Picture at Lucknow, A.D. 1784, by desire of Hussein Reza Caun, Nabob Suffraz Ul Dowlah, who gave it to his friend Francis Baladon Thomas* (surgeon to the Lucknow Residency, dismissed 1784)

Provenance: purchased 1906.
Exhibitions: Whitechapel, 1908 (4); R.A., *The Art of India and Pakistan*, 1947–8 commem. cat. (916).
Literature: W. Foster, *A descriptive catalogue of the paintings statues &c. in the India Office*, 1924, no. 108.

Hasan Reza Khan was appointed minister by Asaf-ud-daula (no. 102) early in his reign. He is said to have been the superintendent of Shuja-ud-daula's kitchen office, and was commonly regarded as an indolent voluptuary. He appears in the *Cock Match*, (no. 104).

He is shown seated on a sofa holding the mouth-piece of a *hookah*, and his right hand rests on the hilt of his sword. The background is interesting as an attempt to Indianise the conventional architectural background of European portraiture for an Indian patron.

India Office Library and Records

104 Colonel Mordaunt's Cock Match 1784–6

Canvas, 102 × 149 (40½ × 58¾)

Provenance: painted for Warren Hastings, sale Fairbrother 26 August 1853 (924); Col Dawkins, Christie's 19 March 1898 (195); Marquess of Tweed-dale, Sotheby, 30 June 1926 (115).
Engraving: mezzotint by R. Earlom, 1792; key published 1794.
Exhibitions: R.A., *The Art of India and Pakistan*, 1947–8 commem. cat. (918); Victoria and Albert Museum, *Art and the East India Trade*, 1970.
Literature: W. Foster, *Walpole Society*, XIX, 1930–1 pp. 82–3; M. Webster, 'Zoffany in India I', *Country Life*, CLIII, 1973, pp. 588–9.

The picture shows a match between the Nawab Wazir of Oudh, Asaf-ud-daula (no. 102), and Colonel John Mordaunt, natural son of the Earl of Peterborough (d. 1790), Commander of the Nawab's bodyguard.

The principal figures, identified in the key to the engraving, are Colonel Mordaunt, dressed in white, who stands at the left of the central group, and Asaf-ud-daula who has risen from a seat on a dais and advanced towards Mordaunt, his hands outstretched. Between them, counting on his fingers, is Salar Jung, Asaf-ud-daula's uncle, and behind Hasan Reza Khan (no. 103). The cock-fighters in the foreground are, on the left, Colonel Mordaunt's, and bending down on the right, the Nawab's. The court of Lucknow, renowned for many extravagances, was especially celebrated for the sports of hunting and cock-fighting in which the Nawab delighted. Mordaunt was a keen cock-fighter, and had brought out from England game-cocks which he was confident would defeat the native-bred cocks. Amongst the European spectators, some in the service of the Nawab, others of the East India Company, are General Martin (no. 105), seated on the dais, talking to Mr Wheler who holds a cock. Behind Martin is John Wombwell (no. 105) with a *nargila* pipe, and to the right sits Zoffany himself, dressed in white holding a pencil. Standing with his hand on Zoffany's shoulder is Ozias Humphry. At the left, Indian feeders and setters-to are watching the fight, and the background is filled with groups of nautch girls, musicians and servants.

The *Cock Match* is deservedly renowned for the vivacity with which it renders a scene of Anglo-Indian life at the brilliant and dissipated court of Oudh. It should not be assumed that the picture is a naturalistic rendering of the scene as it actually occurred.

Some recently discovered contemporary references throw light on the history of this famous composition which was painted for Warren Hastings, Governor-General of Bengal. A note in Hastings' diary records that on 5 April 1784 he was present in Lucknow 'At Mordaunt's Cock fight', and on 3 June Zoffany, whom he had summoned from Calcutta, arrived. (B.L. Add. MS 39879 ff.19, 27v.) In Hastings'

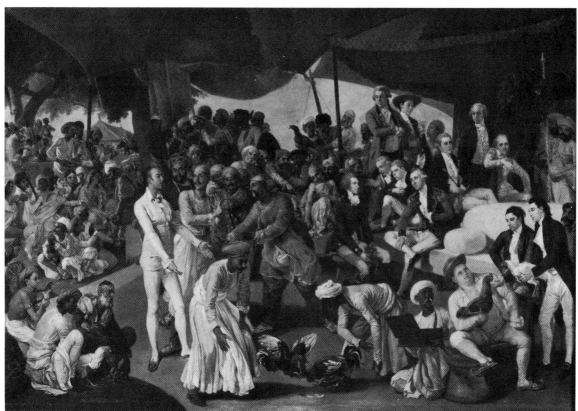

Account Book for 1784–6 (B.L. Add. MS 29229 ff. 153, 194; kindly communicated by Mr Lindsay Boynton) is a copy of Zoffany's bill, rendered in February 1785, for pictures painted or painting for Hastings. It includes an entry: 'For an historical picture of a Cock pitt composed of a great number of small figures . . . Sas [sicca rupees] 15,000' (about £1500). In a letter of 22 February referring to this bill William Larkins, Accountant General and Hastings agent and friend in Calcutta, writes to Hastings who had already sailed for England, 'You will find from the copy of Zoffany's Bill which I sent you in my letter of Yesterday that he has been extremely moderate in the sum which he has charged for the Cock pit in which I understand there is about 90 figures'. Under the terms of a subsequent arrangement Hastings discharged the bill on 14 October 1786, before any of the pictures had arrived in England. They were sent off in at least two consignments; the *Cock Match* may have been included in a box of pictures despatched in February 1788.

Thomas Elmes, writing in 1825, records a story that the ship carrying the original picture of the *Cock Match* was wrecked and the picture lost, and that Zoffany after his return to England in 1789 reconstructed his composition from his original studies and sketches and painted a second version for Hastings. A search among Hastings' papers for the 1790s has failed to reveal a reference to any such occurrence though the papers do show that Hastings paid a social call on Zoffany on 19 March 1791. (B.L. Add. MS 39882 f. 53.)

Zoffany undoubtedly preserved his sketches for the picture since it is well authenticated that he executed another version of it for the Nawab Wazir which remained at Lucknow until the Mutiny of 1857. The existence of another version of the subject with many fewer figures and with alterations in composition and setting is also attested by a picture in a private collection (known as the Strachey or Ashwick version). The agreements between the 'about 90' figures mentioned by Larkins and the number of figures in the picture exhibited must throw some doubt on Elmes' story of the shipwreck.

In the opinion of the compiler this is the picture which was painted for Hastings and begun in Lucknow in 1784. That Zoffany continued to work on it during his second stay in Lucknow from 1785 to 1786 is suggested by the presence of Ozias Humphry, who arrived in Lucknow in February 1786 and left by the autumn. Although the picture was clearly in an advanced state by the time the bill was rendered in February 1785, its actual completion, like that of *The Tribuna*, was no doubt long drawn out.

Private collection

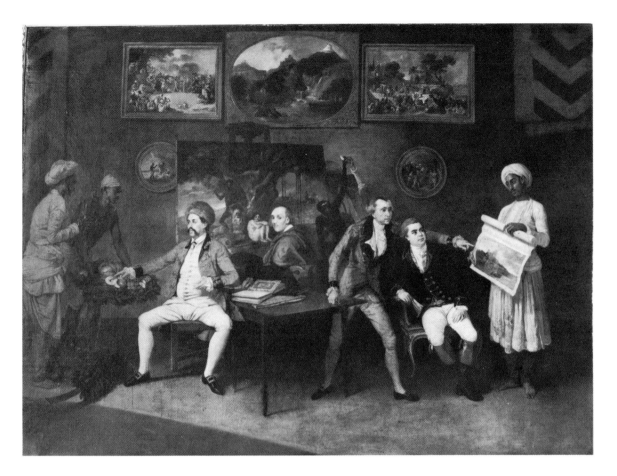

105 Colonel Polier with his friends 1786

Canvas, 137 × 183.5 (54 × 72¼)

Provenance: probably Edward Strachey (second assistant to the Resident at Lucknow 1797–1801); given by his son Captain Henry Strachey *c.* 1850 to Robert Henry Clive in satisfaction of a debt, by descent to his nephew Viscount Bridgeman, sale Christie's 28 June 1929 (75).

A circle of Lucknow friends with Zoffany at the easel. Standing to the right of the table is General Claud Martin (1735–1800), a Frenchman who rose to fame and fortune in eighteenth-century India. In 1779 he left the active service of the East India Company and entered that of the Nawab Wazir at Lucknow. Martin was a man of exceptional gifts and cultivated tastes, among them the collecting of pictures and the study of Indian customs and antiquities. Here Zoffany shows him pointing out features of a water-colour of his house, the Farad Baksh on the river Gumti, to his friend John Wombwell, the East India Company's Accountant at Lucknow.

On the opposite side of the table sits Colonel Anthony Polier (1741–95), a Swiss of French descent, who became an engineer in the Company's service in 1762, resigning when he was refused promotion and entering the service of the Nawabs of Oudh. Later Hastings made him a Lieutenant-Colonel in the Company's service with leave to reside at Lucknow. A patron of Hodges, he too was interested in Indian religion and antiquities and is said to have been the first European to have obtained a complete collection of the Vedas. His left elbow rests beside an open illuminated oriental manuscript lying on a book of prints. Two servants have brought in a basket of fruit and vegetables from which he is ordering the day's provisions. This gesture indicates that the scene is taking place in his house in Lucknow.

Behind Zoffany a servant is giving a pet monkey a banana. The picture Zoffany is painting is a group of Hindu devotees seated under a banyan tree. Hanging on the wall behind are other pictures: to the left a Hindu cremation scene, in the centre a mountain landscape with elephants being washed by their keeper, to the right pilgrims bathing in a river. The two small circular pictures represent left, a funeral pyre, and right, a battle with a horseman. On the extreme left and right are bamboo blinds covered with material, of a type peculiar to Lucknow.

This picture has been wrongly identified as a painting of 'Colonel Polier, General Martin and a Native Planter', listed without the name of an artist in the 1801 Inventory of Martin's effects. (India

Office, Bengal Inventories, 1801, Vol. I, Range 1, no. 76, f. 49.) The word read as 'Planter' is a copyist's mistake for Painter, and that particular picture was evidently one of the many works by Indian artists in Martin's collection. This confirms the probability that the room represented is one in Polier's house in Lucknow, a probability also strengthened by the fact that none of the pictures shown hanging on the wall – which are certainly by Zoffany – can be identified in Martin's inventory.

The picture is a fascinating record of quite another side of European life in Lucknow from that shown in the *Cock Match*. It was probably painted towards the end of Zoffany's second residence in Lucknow, from mid 1785 to November 1786 when he left with Polier for Calcutta.

Victoria Memorial Hall, Calcutta

106 General Norman MacLeod of MacLeod
1787

Canvas, 244 × 160 (96 × 63)

Provenance: by descent.
Literature: Journal of the Society for Army Historical Research, XLV, no. 184, 1967, pp. 226–30. (Kindly communicated by Mr A. V. B. Norman.)

Norman MacLeod of MacLeod (1754–1801) succeeded as 23rd Chief in 1772, and was host to Johnson and Boswell on their famous vist to Dunvegan in September 1773. To clear the difficulties in which the MacLeod estate was involved he raised a company for the new 71st Regiment (Fraser Highlanders) and embarked for America in 1776. He was taken prisoner on the voyage out and after his return to Scotland in 1779 was made Lieutenant-Colonel of the Second Battalion of the 42nd Highlanders, the Black Watch, raised by himself. He arrived at Madras in 1782 and played a successful part in the second Mysore war against Tipu Sultan. The scar which appears on MacLeod's temple is claimed by family tradition to have been the result of a stormy meeting in which MacLeod tried to make Tipu fulfil the obligations of the truce of 1784. Tipu, who invited MacLeod to share his evening meal while continuing the discussions, suddenly in a furious passion ordered the lights to be put out, and fired a pistol point blank at his guest. In 1785 MacLeod was appointed Second-in-Command of the whole Indian Army and lived for three years in splendour in Bengal. He resigned and returned to Dunvegan in 1789.

It is virtually certain that this is the picture which he mentions in a letter from Calcutta of 19 January 1787 to his wife (no. 107). 'My picture is nearly finished; it is like, very like, but too handsome'. The identification is confirmed by the uniform he wears; this is the new uniform which his battalion adopted by royal command at Dinapore in April 1786, when it was formed into a separate corps and designated the 73rd Highlanders. Zoffany has shown MacLeod holding the

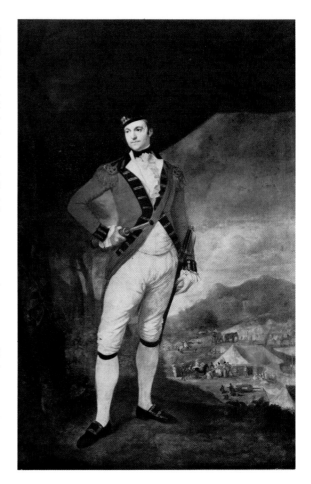

spy-glass of a commander, and with the encampment of an army in India in the background. These motifs may allude to the General's role in the Mysore war.

Since Zoffany only returned to Calcutta early in December 1786 the picture cannot have been begun before this date. The fact that it is painted extremely thinly suggests that it was painted quickly; the background is particularly sketchy. The picture is, however, one of Zoffany's most striking full-length portraits; the single figure is portrayed with all the animation more usually associated with his groups.

(I am indebted to Mrs Wolridge-Gordon for her kind assistance in connection with the portraits of the General and his wife, and to Mrs Gouldesbrough for communicating excerpts from the General's correspondence.)

Dunvegan Castle

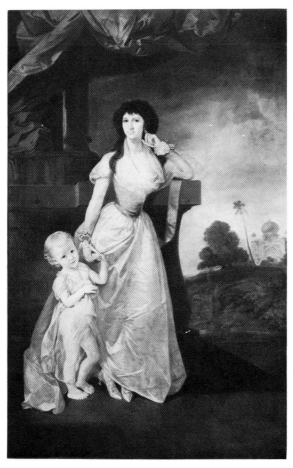

107 Sarah, second wife of Norman MacLeod
1787

Canvas, 244 × 160 (96 × 63)

Provenance: by descent

A companion portrait to no. 106. MacLeod married as
his second wife, Sarah (1767–1829), seventeen-year-
old daughter of Nathaniel Stackhouse, a prominent
member of the Bombay government, at the end of 1784.
She is shown here with their eldest child Sarah (born
by 3 October 1785–1806). The little girl has hitherto
been regarded as a later addition, having been wrongly
identified as John Norman (b. 3 August 1788). A signed
and dated miniature of 1787 by Diana Hill, an English
lady miniaturist working in Calcutta, now at
Dunvegan, shows the same child as in Zoffany's
picture, at the same age.

The painting must have been executed in 1787
shortly after the portrait of General MacLeod. Here
too the figure in her brilliant pink dress is realised in
striking relief.

Dunvegan Castle

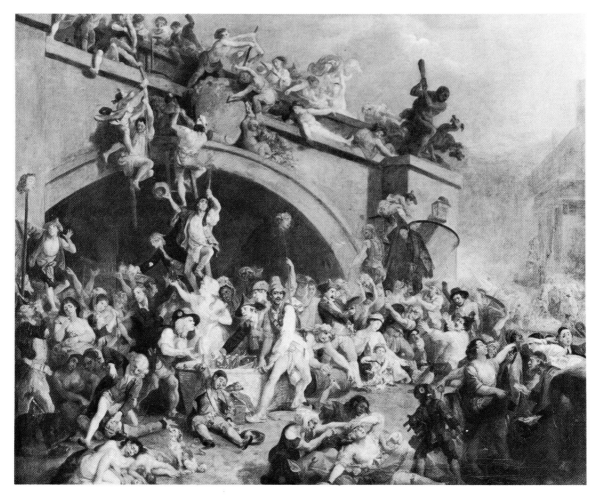

108 Plundering the King's Cellar at Paris 1794

Canvas, 103 × 126.5 (40½ × 49¾)

Provenance: Zoffany's sale, Robins 9 May 1811 (94);
Christie's 30 November 1867 (88).
Engraving: mezzotint by R. Earlom, 1795.
Exhibitions: R.A., 1795 (18); R.A., *The First Hundred
Years*, 1951–2 (63).

As contemporary critics immediately grasped, the
picture is a savage satire on the horrors of the French
Revolution. Zoffany has invented a composition which
exposes the rhetoric of the Revolution by showing the
aftermath of the sacking of the Tuileries on 10
August 1792 (not 1793 as stated on the engraving). On
that fateful day the populace forced its way into the
palace, massacred the Swiss guards and liveried
servants, and ransacked the entire building, from
roof-top to cellar. The heads on pikes indicate that
their victory is complete and they are now abandoning
themselves with callous brutality to drunkenness and
destruction.

Earlier a tolerant, even sceptical figure of the
eighteenth-century enlightenment, Zoffany became
ultra-conservative in reaction to the massacres of 1792
which turned so many Englishmen, originally
sympathetic, against the French Revolution. He clearly
painted more than one picture attacking Revolutionary
France, for Farington records in a diary entry about the
present picture that: 'He was painting on one of his
Parisian subjects, – the women & sans 'culottes,
dancing &c over the dead bodies of the Swiss soldiers'
(1 August 1794), and two others were included in
Zoffany's sale, Robins 9 May 1811 (59, 85).

The picture was naturally received with sharply-
worded hostility by radical critics. Anthony Pasquin
was the most bitter, but with his usual acuteness
observed that 'of all the pieces I have seen from the
pencil of Mr. Zoffanii, this is the most unlike himself;
he evidently labours to tread in the steps of Mr.
Hogarth'. (*Authentic History of the Artists of Ireland*,
1796, pp. 35–6 n.).

The picture can now be recognised as one of
Zoffany's most striking and unexpectedly powerful

inventions, with its mingling of the grotesque and the horrible.

Private collection

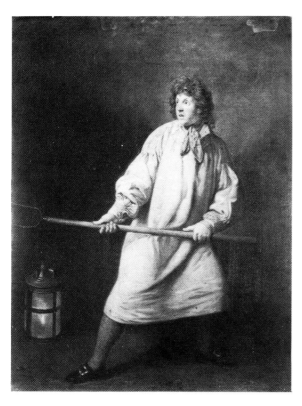

109 Thomas Knight in 'The Ghost' *c.* 1795–6

Canvas, 61 × 49 (24 × 19¼)

Provenance: Zoffany's sale, Robins 9 May 1811 (88), bt. C. Matthews whose collection was purchased by the Garrick Club 1835.
Exhibitions: R.A., 1796 (110); R.A., *The First Hundred Years*, 1951–2 (147).
Literature: C. K. Adams, *A Collection of Pictures in the Garrick Club*, 1936, no. 116.

Thomas Knight (?1764–1820) as Roger, the frightened countryman in *The Ghost*, a comic afterpiece adopted from Mrs Centlivre's play *The Man's Bewitched*, acted at Covent Garden on 19 October 1795.

Knight was a comedian and playwright who excelled in roles of coxcombs and rustics. He acted chiefly at Covent Garden.

The Garrick Club

110 Scene from 'Speculation' *c.* 1795–6

Canvas, 90 × 124.5 (39 × 49)

Provenance: Zoffany's sale, Robins 9 May 1811 (92), bt. C. Matthews whose collection was purchased by the Garrick Club 1835.
Exhibition: Arts Council, *Johann Zoffany*, 1960 (2).
Literature: C. K. Adams, *A Catalogue of Pictures in the Garrick Club*, 1936, no. 104.

Tanjore played by William Lewis (?1748–1811) stands at the left in the scene where John Quick (1748–1831), as the gentleman farmer Alderman Arable, discovers that Project, played by Joseph Munden (1758–1832), has made a dupe of him by involving the Alderman's niece Emmeline's fortune in his speculations. Alderman: 'Oh you consummate scoundrel! this is your speculation is it' (Act IV Scene ii). *Speculation*, a comedy by F. Reynolds, was first performed at Covent Garden in September 1795, and ran throughout the season with a command performance.

According to the original stage directions the scene took place in an apartment in the Alderman's house containing a round table, two chairs, pen, ink and paper, and hung with pictures. These included a portrait of the Alderman in his gown and full dressed wig leaning on a plough – Zoffany has shown him with a hoe.

Hazlitt records an anecdote about Zoffany being employed by George III to paint a scene from *Speculation* (*The Complete Works of William Hazlitt*, ed. P. P. Howe, 1930, XVII, p. 226), and Zoffany's sale catalogue alludes to this picture as having been painted for a 'distinguished personage'. Both state that Miss Wallis as Emmeline was included in the picture, and the present grouping of the figures is additional evidence that a figure has been painted out. Moreover the sale catalogue notes the picture as unfinished. Presumably therefore the screen, table and bust to the right were added, and the figure of Tanjore may have been finished by another hand while the picture was in Charles Matthews' collection.

The Garrick Club

111 The Death of Captain Cook *c.* 1795

Canvas, 137 × 183 (54 × 72)

Provenance: given to Greenwich Hospital 1835 by Mr J. K. Bennett, the executor of Captain Cook's widow.
Exhibition: Arts Council, *The Age of Neo-Classicism*, 1972 (286).
Literature: C. Mitchell, *Burlington Magazine*, LXXXIV, 1944, pp. 56–62; B. Smith, *European Vision and the South Pacific*, 1960, p. 84.

The death of Captain Cook, which occurred at Karakooa Bay in Hawaii on 14 February 1779, was the

subject of several paintings derived from first-hand accounts of the event. Zoffany has transformed his version, which relies for some of its detail on the official account of 1784, into a historical composition in the classical heroic mode. The central group forms a pyramid over the figure of Cook, who is shown in the pose of the *Dying Gaul* (Capitoline Museum). The murdering savage, for all his Hawaiian helmet, is based on Towneley's *Discobolus* (see no. 95). There are also classical reminiscences in the other figures of the Hawaiians. Shown on the rock to the right are the seated chief Terreeoboo, one of his wives and two subordinate chiefs. In this unfinished picture, only the Marine on the left and the three savages in the foreground have been worked up; the figure of Cook is partially completed. The figures in the background and the landscape are little more than roughed out.

Zoffany's sole heroic composition, probably painted *c.* 1795, and certainly after 1792 when Towneley's *Discobolus* arrived in London. The idealisation of the naked forms of the Hawaiians must derive from the eighteenth century's cult of the noble savage – compare the treatment of the Parisian mob in no. 108.

National Maritime Museum, Greenwich

112 John Heaviside (*c.* 1795)

Mezzotint by Richard Earlom, 1803
50.5 × 35.5 (19⅞ × 14)

Literature: C.S., p. 250, no. 22; *Print Collector's Quarterly*, XVII, p. 250.

John Heaviside (1748–1828), a surgeon who established a well-known practice in London, holding a heart on which he is lecturing. One of his most famous patients was Lady Hamilton. In 1787 he inherited a fortune and bought a house in Hanover Square where he built up a museum of anatomy and natural history. Appointed Surgeon-Extraordinary to George III in 1790.

When the mezzotint was scraped the portrait of Heaviside, whose whereabouts is now unknown, was in the possession of Zoffany's son-in-law John Doratt, a surgeon.

Victoria and Albert Museum

113 The Death of the Royal Tyger (*c.* 1795)

Mezzotint by Richard Earlom, published 1802; key to the figures published 1802
53.5 × 68 (21⅛ × 26¾)

Literature: C.S., p. 261, no. 50; M. Webster, 'Zoffany in India II', *Country Life*, CLIII, 1973, pp. 688–9.

Zoffany is known to have been meditating at least one picture of a tiger hunt by April 1784, when Sir John Day described in a letter an actual tiger hunt at Chinsura in which the artist took part. The four tigers killed in this hunt were exhibited on the triumphant return of the hunters to their encampment: 'The natives viewed them with terror, and some with tears. There was a very affecting incident which so fastened upon Zoffani's imagination, and so touched his heart, he means to give it a principal place in a picture which he meditates upon the subject'. (J. Forbes, *Oriental Memoirs*, II, 1813, pp. 489–95). This must be the same picture as that mentioned by Lady Day in a letter about the hunt, written on 2 May 1785: 'Zoffany is making a delightful picture of it in which he has introduced portraits of the whole party'. (India Office, *Cat. MSS in European Languages*, II, pt. ii, p. 145, 26/78.) It can plausibly be connected with the unfinished sketch of the *Return from the Tyger chase* included in Zoffany's sale (Robins 9 May 1811 (59)).

The picture from which the present print was taken was also in Zoffany's sale (95). According to the caption on the print, it is a representation of a hunt held at Chandernagore in 1788; however this date does not agree with the dates of residence in India of the persons identified as taking part. In the howdah of the elephant on the right is Sir John Macpherson with Zoffany beside him, and on the left are General John Carnac and Mr John Stables. The picture is therefore much more probably a reminiscence of the tiger hunts in which Zoffany took part with some of his closest friends, and was probably painted after the artist's return to England, from sketches made on the spot. The only known version of the composition, which once belonged to Zoffany's friend Wetten, is now in the Victoria Memorial Hall, Calcutta.

India Office Library and Records

114 Hyderbeg on his mission to Lord Cornwallis (1796)

Mezzotint by Richard Earlom, 1800
53.5×68 (21⅛×26¾)

Literature: C.S., p. 260, no. 49.

The original picture from which this engraving was made was exhibited at the Royal Academy in 1796 (125) and is now in the Victoria Memorial Hall, Calcutta (probably Zoffany's sale, Robins 9 May 1811 (96)). The animated grotesque figures closely resemble those of *Plundering the King's Cellar* (no. 108).

The scene depicted is a vivid genre incident, showing the destructive powers of a furious elephant, which occurred during the journey of the embassy sent by Asaf-ud-daula, Nawab Wazir of Oudh (no. 102), in 1787 (not 1788 as stated on the print) to the Governor Lord Cornwallis to ask for a reduction in the contributions levied from Oudh. The Ambassador was Haider Beg Khan, Chief Minister to Asaf-ud-daula. He is known to have left Lucknow in October 1787, about a fortnight before Zoffany, who probably caught up with the heavy, slow-moving train on its journey, and has included himself on horseback at the right of the composition. (R.A., *Ozias Humphry Correspondence*, III, 114.)

Zoffany's choice of this lively incident shows his delight in the picturesque humours of Indian life. The scene is set near Patna, since Zoffany has shown on the left the famous huge *gola* or granary, erected by order of Warren Hastings and completed in 1786. In spite of such realistic detail, however, the landscape is artificial; no hills exist in the flat Ganges plain.

The composition with its double file of figures uses a device for depicting long processions traditional since the sixteenth century.

The Trustees of the British Museum

115 Title-page (1797)

Line engraving by J. Stow
32.5×23.1 (12¾×9⅛)

Decorative title-page to *Attempts to compose six Sonnets and Six Sonatinas* most humbly dedicated by Permission to Her Royal Highness the Princess Elizabeth. by Master W. E. Southbrook. Published 29 September 1797.

William Southbrook, a young composer, being presented by the figure of Genius to Apollo.

The Trustees of the British Museum

Graphic work

116

116 Samson overcome by the Philistines *c.* 1758

Etching, 16.5×25 ($6\frac{1}{2} \times 9\frac{7}{8}$)
Lettered: *J. Zauffalij. inv: et fecit. N3*

Delilah, seated at the left, holds a pair of shears and the locks cut from Samson's head, while the Philistines, into whose hands she has delivered him, violently lay hold on him and put out his eyes.

Zoffany executed three etchings of historical subjects; no examples of the other two – *The Death of Lucretia* and *The Death of Virginia* – have so far been traced. Presumably datable to the late 1750s, shortly before Zoffany left Germany for England. The execution is somewhat mechanical.

The Trustees of the British Museum

117 Allegory of the Dawn *c.* 1759

Black and white chalk on brown grey paper,
28×45.1 ($11 \times 17\frac{3}{4}$)
Inscribed in an old hand on the guard at time of purchase with the name of Zoffany.

Provenance: Sir Frederick Gore Ouseley, Tenbury; bt. from F. W. Barry.

On the left is Phoebus Apollo in his chariot with the dance of the Hours below; preceding the chariot is Aurora who dismisses Night. Two putti carry a rayed sun-disk. A design for a ceiling decoration, with a sketch of the ground plan of the room for which it was intended, lower right.

Zoffany is known to have painted decorations in both fresco and oil for the Elector of Trier in 1759–60. He decorated three rooms of the newly built Residenz in Trier – the Elector's bedroom, the audience room and a drawing-room. For the two latter he painted the ceilings in fresco. The work was completed by 3 March 1760. (K. Lohmeyer, *Johannes Seiz, 1717–1779*, Heidelberg, 1914, p. 86.) It is possible that this drawing, no. 118, and a drawing for the same ceiling design now in the Royal Library (A. P. Oppé, *English Drawings in the Collection of His Majesty The King at Windsor Castle*, 1950, no. 699), may be connected with Zoffany's work at Trier (destroyed).

The Trustees of the British Museum

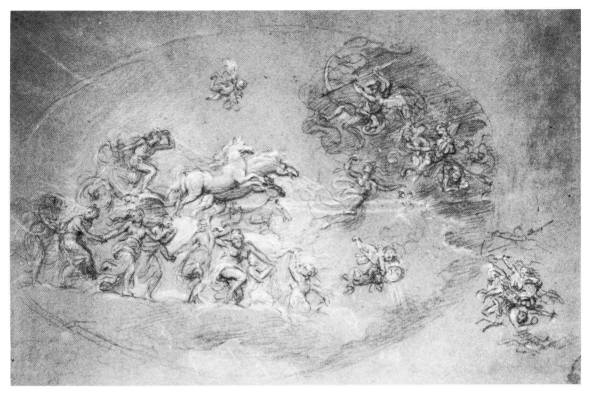

118 Allegory of the Dawn *c.* 1759

Black and white chalk on brown-grey paper,
$28 \times 44.8 \left(11 \times 17\frac{5}{8}\right)$
Inscribed in an old hand on the guard at the time of
purchase with the name of Zoffany.

Provenance: Sir Frederick Gore Ouseley, Tenbury;
bt. from F. W. Barry.

See no. 117. A later design for the same ceiling.

The Trustees of the British Museum

119 Triton and Nereid *c.* 1759

Black and white chalk on brown paper,
$22.3 \times 35.2 \left(8\frac{3}{4} \times 13\frac{7}{8}\right)$

Provenance: Sir Frederick Gore Ouseley, 1919.
Literature: A. P. Oppé, *English Drawings in the
Collection of His Majesty The King at Windsor Castle,*
1950, no. 701.

A design for an unidentified architectural decoration,
a coved frieze. Possibly connected with Zoffany's work
for the Elector of Trier. See no. 117.

Her Majesty Queen Elizabeth II

120 Venus, Cupids and Satyrs *c.* 1759

Black and white chalk on grey paper,
$35 \times 31.5 \left(13\frac{3}{4} \times 12\frac{3}{8}\right)$

Provenance: Sir Frederick Gore Ouseley, 1919.
Exhibition: R.A., *Bicentenary Exhibition 1768–1968,*
1968–9 (658).
Literature: A. P. Oppé; *English Drawings in the
Collection of His Majesty The King at Windsor Castle,*
1950, no. 700.

A preliminary study for a decorative painting designed
to be viewed from below. Possibly connected with
Zoffany's work for the Elector of Trier. See no. 117.

Her Majesty Queen Elizabeth II

121 A musical party *c.* 1765

Pen and ink, 13.5×16.5 (5⅜×6½)
Inscribed on the verso by Francis Douce: *Certainly by Zoffani*

Provenance: Francis Douce 1816, by whom bequeathed 1834.

In the absence of documented comparative drawings, this sketch of a musical conversation piece, with its early attribution to Zoffany, may be considered as an example of the type of preliminary study that he made for his group portraits.
An entry in Douce's *Diary of Antiquarian Purchases* for August 1816 reads: 'a drawing by Zoffany'.

The Visitors of the Ashmolean Museum

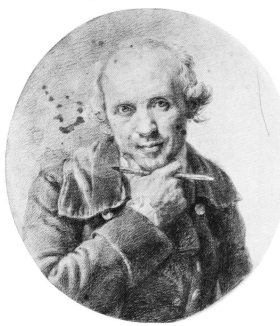

122 Self-portrait *c.* 1775

Black chalk on white paper, 30.5×28 (12×11) oval

Provenance: Gabriel Mathias by descent to Miss Lettice A. MacMunn, from whom purchased 1927.
Exhibition: R.A., *Bicentenary Exhibition 1768–1968*, 1968–9 (526).
Literature: C. Dodgson, 'John Zoffany, RA, 1733–1810', *Old Master Drawings*, II, 1928, p. 64.

Probably connected with the self-portraits Zoffany painted during his stay in Italy (Florence, Uffizi; Cortona, Accademia Etrusca; Parma, Galleria) which all have in common the slight tilt of the head. The chin resting on the hand holding a porte crayon is close in attitude to a self-portrait in the Uffizi (fig. 2) of 1775, and it has a similar air of sophisticated informality, but a greater degree of feeling. The coat that he wears with its very wide soft collar is probably an artist's painting robe. Gabriel Mathias (d. 1804) to

whom Zoffany apparently gave this drawing was a portrait and genre painter. He held an appointment in the office of the Privy Purse and it was through him that George III paid subsidies towards the upkeep of the Royal Academy.

The Trustees of the British Museum

123 Self-portrait 1782

Black and red chalk, 29.7×24.2 (11¾×9½) oval
Inscribed: *Zoffany/1782*

Provenance: by family descent to Miss S. J. Beachcroft, great granddaughter of the artist. On loan to the Fitzwilliam Museum 1922–30; Christie's 6 July 1934 (10); bt. 1934.
Exhibition: Arts Council, *British Self-Portraits*, 1962 (35).
Literature: G. C. Williamson, *Catalogue of the Beachcroft Collection*, title-page.

A formal, highly finished self-portrait, now in poor condition having been framed and long exposed to daylight whilst in the possession of Zoffany's descendants.

The Visitors of the Ashmolean Museum

124 Asaf-ud-daula, Nawab Wazir of Oudh 1784

Black, white and red chalk on brown paper, 21.7×15.2 (8¼×6⅛)
Inscribed: *Nabob of Oude*

Provenance: bought by the Prince Regent from Colnaghi on 5 June 1811.
Literature: A. P. Oppé, *English Drawings in the Collection of His Majesty The King at Windsor Castle*, 1950, no. 698.
Exhibition: R.A., *The Art of India and Pakistan*, 1947–8, commem. cat. (915).

For the sitter see no. 102. A study from the life of the Nawab who sat to Zoffany in June and July 1784. (B.L. Add. MS 39879 ff.29v–31.) The inscription appears to be in Zoffany's hand. Perhaps one of the drawings from Zoffany's studio sale (Robins 9 May 1811 (26)).

Her Majesty Queen Elizabeth II

125

125　At Najafgarh Ghat 1788

Red, black and white chalk on grey paper,
23.3 × 34.6 (9⅛ × 13⅝)
Inscribed on the verso by Zoffany: *Najef Gar belonging to Collonel Martin/a Jagir Reigth/ to Haeng . . . or Return them to a curry . . ./Carta Bibbel Nov. 17. 88.*

Provenance: Brigadier Hutchinson, Major R. G. Hutchinson; Sir Bruce Ingram.
Exhibition: Ashmolean Museum, *Exhibition of English Drawings purchased from the Ingram Collection,* 1963 (100).

Presumably an outbuilding or rest house at Colonel Martin's residence at Najafgarh Ghat on the banks of the Ganges, a few miles below Cawnpore. This drawing was made on Zoffany's last journey down the Ganges on his way back to Calcutta and thence to England.

The Visitors of the Ashmolean Museum

126　Group of buildings surrounding a 'suttee' memorial 1788

Black, red and white chalk on faded blue paper,
28.5 × 35.2 (11¼ × 13⅞)
Inscribed by Zoffany: *Mirza Bour Nov 27 1788* on the verso: *to commemorate . . . have burnt themself loss* [?] *the Death of their Husband. Erected by the Nearest Relation and considert as . . . and have lamps burnt Every Nigth Nov. 27 88 J. Zoffany*

Provenance: Brigadier Hutchinson, Major R. G. Hutchinson; bt. 1955.

Two paintings of 'suttee' scenes were included in the sale of Zoffany's studio (Robins 9 May 1811 (11, 12)).
 Drawn at Mirzapore on Zoffany's way down to Calcutta.

The Trustees of the British Museum

127 A Hindu brought to the Ganges to die 1788

Black, red and white chalk on blue-grey paper,
27 × 34.6 (10⅝ × 13⅝)
Inscribed on the verso: [?] *28 Aug. Distance a Hindu
brought to the Watter to Die/his Daughter officiating the
Death* [?] *benevolent service Doth/give him so much
Ganges Watter till it stops his Breath/being Given up by
their Docttors this Man Deith Very hard/to the River
being weary Long I saw him Die/Nov 29–88 in sigth
Bazar – Captain Hardaph/B. Zoffany.*

Provenance: Brigadier Hutchinson; Major R. G.
Hutchinson; A. R. Pilkington.

This fine drawing reflects Zoffany's interest in Hindu
customs. To die by the sacred Ganges is still a
privilege for the devout Hindu.

*Yale Center for British Art and British Studies,
Paul Mellon Collection*

128 Mountainous landscape in India 1788

Black, red and white chalk on faded blue paper,
27.1 × 34.1 (10⅝ × 13⅜)
Inscribed on the verso by Zoffany: [largely illegible,
but including] *2 Fagal are trying to thro a Eck* [egg] *of
stone down the height . . . of the Deity . . . taken of the
Pagoda at the death of the . . . in the solid Rock 300 yard
deep . . . the Pagoda is wound* [?] *up to a Rock 80 yard
high . . . Pagoda 3. 1788*

Provenance: Brigadier Hutchinson, Major R. G.
Hutchinson; bt. 1955.

Drawn on Zoffany's last journey down the Ganges to
Calcutta late in 1788, perhaps 3 December.

The Trustees of the British Museum

**129 Old trees and rocks with Indians drawing
water** *c.* 1788

Red, black and white chalk on grey paper,
26.7 × 34.6 (10½ × 13⅝)

Provenance: Brigadier Hutchinson, Major R. G.
Hutchinson, 1955.

An example of a sketch from nature in a picturesque
taste, of a curiously bent and twisted tree.

Witt Collection, Courtauld Institute of Art

130 A Fakir standing in a river below an overhanging tree and rock *c.* 1788

Red, black and white chalk on grey paper,
28.5×34.3 (11⅛×13½)

Provenance: Brigadier Hutchinson, Major R. G. Hutchinson, 1955.

A sketch from nature which shows Zoffany's interest in the details of Indian landscape. Probably drawn during one of his journeys on the Ganges between Calcutta and Lucknow.

Sir John and Lady Witt

131 A Muslim tomb and riverside scene with elephants watering *c.* 1788

Red, black and white chalk on grey paper,
21.5 × 42.5 (8½ × 16¾)

Provenance: Brigadier Hutchinson, Major R. G. Hutchinson; Sir Bruce Ingram.
Exhibition: Leger, *English watercolours and drawings from the collection of Theodore Besterman,* 1969 (81).

A reflection of Zoffany's interest in scenes of everyday life in India.

Dr Theodore Besterman

132 View of an Indian village *c.* 1788

Black, red and white chalk on blue paper,
27.7 ×47.9 (10⅞×18⅞)

Provenance: Brigadier Hutchinson, Major R. G. Hutchinson.

The Trustees of the British Museum

133 View on the Danube 1791

Black chalk on brown paper, 25.4×39.4 (10×15½) irregular
Inscribed on the verso: *Friday 21 1791, Wirbal on the Donau*

This sketch of a landscape and a covered boat on the Danube is our only evidence of Zoffany's visit to southern Germany in 1791. It was probably drawn in October; the other month of 1791 in which the 21st fell on a Friday is January, which would have been difficult for travelling.

The Trustees of the British Museum

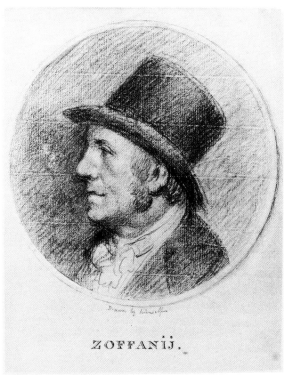

ZOFFANIJ.

134 Self-portrait *c.* 1795

Pencil, 15.2 (6) diameter
Inscribed: *Zoffanij.* and in a later hand: *Drawn by himself*

Provenance: given by I. A. Williams, 1932.

A dating of *c.* 1795 is suggested by comparison of this drawing with the portrait of Zoffany in Henry Singleton's *Royal Academicians in General Assembly* of that year (Royal Academy). Flat-top hats were generally worn at this time.

National Portrait Gallery, London

Additional material

135 Letter from Zoffany to Charles Towneley

Lucknow the 28 Nov 1784

Monsieur,
 Conoschento il Suo bon Core e la amicicia che me monstrado nel mio Sogiorno a londra mi Fa prendere la Liberta di Incomodarla con quete Rige. Io arivay in Madras dopo un Wiagio di quattro Mesi e ni tratene 5 Settimane (Free?) Fece qualce Lavoro e Continuai per la mia testinacione a Calcutta dove Ebe assay di occupacione. al principio de Messe di magio Fiy Ciamato dal Governatore Mr Hastings per dipincere il Yessir e el Fillio del Impradore di Delli e molti altri quel che il Milgio che ho Semper avullo bona Salutte – ma el denaro e Scarso come so che non me posso melgio adrizar e Che a Voj Sig^ra Ec^m. Come un Melgio Gudice neli belli arti e avendo spesso barlatto dela Sua prezioza Colectione – un amico Colonel Martin un omo molto conoschiuto in Ingiltera per il Suo Genio ne le scence e le suoi actioni nel Militare. me prego di Volere Incomodare Con una bicula Comissione e Ecolo la La Sua lettere e una Campiale di 400 Lire Sterline e La Lettera le informera qulche il desidárare in Soma quel che si buole avere por la Soma, Eschusi la Liberta il Colonello si Fara il piu Grand Piacere Se Fosse qualche Cossa in questo Paiesse si Suo piacere – in tanto mi Volia bene Con Che Resto
 Monsieur, your Mosth obedient Serv^t.
 Jn Zoffany
me Complimeny al Weckio Mr Danckervile

The only known letter in Zoffany's hand. Addressed to his friend Charles Towneley (no. 95) whom he met in Italy, it shows clearly that Zoffany was not only more familiar with Italian, his second language, than with English, his third, but also that his knowledge was of the spoken rather than written tongue.
 Zoffany forwards a letter from Colonel (later General) Martin (no. 105) asking Towneley to purchase for him works of art for £400. Zoffany tells Towneley that he arrived after a four-month journey for a stay of five weeks in Madras, where he painted several pictures and went on to Calcutta and found enough work. At the beginning of May, Hastings called him to Lucknow. He had good health, but money was scarce.

Private collection

136 Portrait of Zoffany *c.* 1765

Miniature, ivory, 3.8 × 3.2 ($1\frac{1}{2} \times 1\frac{1}{4}$)

Provenance: by descent.

Wearing Van Dyck costume, Zoffany is shown here at about the age of thirty. There is no evidence in support of the tradition that this is a self-portrait.

Dr E. Forbes Roberts

137 Portrait of Zoffany *c.* 1780

Miniature, ivory, 3.5 × 2.8 ($1\frac{3}{8} \times 1\frac{1}{8}$)
Inscribed on a piece of paper stuck on the back: *My Father*

Provenance: given by Zoffany to his youngest daughter, Laura Helen Constantia (1795–1876), by descent to Oliver Jones by whom presented 1954.

According to Zoffany's granddaughter, Mrs Edwin Oldfield (1832–after 1920), Zoffany presented a self-portrait miniature to each of his four daughters. This miniature is in a gold frame which has the initials J.M.L.C.L. engraved on it, and the back is said to have contained the hair of five persons (Manners & Williamson, p. 224). The initials may stand for Johan, Mary, Laura Constantia and Lewis – Zoffany and his wife, his youngest daughter Laura and her husband Lewis (Oliver). There is no evidence in support of the tradition that this is a self-portrait.

Victoria and Albert Museum

138 Portrait of Zoffany *c.* 1790

Miniature, ivory, 8.9 × 7.6 ($3\frac{1}{2} \times 3$)

Provenance: by descent.

Stated by family tradition to be a self-portrait, painted after Zoffany's return from India (Manners & Williamson, p. 178). From the age of the sitter a date of *c.* 1790 appears correct, but this miniature is unlikely to be a self-portrait. John Alefounder (d. 1794) sent from Calcutta to the Royal Academy a miniature of Zoffany which was accepted as a late entry to the exhibition of 1793 (476); in the absence of comparative material only a very tentative connection with Alefounder's miniature can be suggested.

Dr E. Forbes Roberts

Literature: A. H. Smith, *Catalogue of Sculpture in the Department of Greek and Roman Antiquities, British Museum*, III, 1904 (to which the numbers in brackets refer).

The following marbles from the Towneley Collection appear in no. 95 (*q.v.*). The titles are taken from a list drawn up by Charles Towneley for Zoffany.

a **A Bust of Minerva** (1571)
Marble, 82 (32¼) high
Found in the Villa Casali at Rome in 1782. The helmet and breast are restorations by Albercini.

b **A Bust of Isis** (1874)
Marble, 68.5 (27) high
Towneley's favourite bust, which he also called by the name of Clytie. Purchased in 1772.

c **A Head of a Hero** (1860)
Marble, 70.4 (27¾) high
Found by Gavin Hamilton in 1771 at Hadrian's Villa. Now thought to represent a companion of Ulysses.

d **Terminal Bust of Homer** (1825)
Marble, 57 (22½) high
Found at Baiae, 1782. Greatly admired by Towneley.

e **A statue of a young Bacchus leaning on his genius, Ampelus** (1636)
Marble, 149.5 (58⅞) high
Found near La Storta, 1775. Now thought to represent Dionysus and the personified vine.

The Trustees of the British Museum

Index

List of lenders

Her Majesty Queen Elizabeth II 9, 24, 25, 62, 63, 68, 69, 71, 72, 74, 76, 82, 119, 120, 124
Aberdeen Art Gallery 101
Thomas Agnew & Sons Ltd 79
The Visitors of the Ashmolean Museum 58, 121, 123, 125
The Duke of Atholl 31
Dr Theodore Besterman 131
Birmingham City Museums and Art Gallery 33
Musée des Beaux-Arts de Bordeaux 6
Bowood Collection 38
Royal Pavilion, Art Gallery and Museums, Brighton 97
The Trustees of the British Museum 37, 44, 66, 67, 91, 114–18, 122, 126, 128, 132, 133, 139
Cadland Settled Estate 55
Mrs R. H. Cobham 88
Edward Croft-Murray, Esq 49
R. H. N. Dashwood, Esq 100
Arthur Richard Dufty, Esq 22
Dunvegan Castle 106, 107
The Lord Egremont 13
A. B. L. Munro Ferguson of Raith and Novar 52, 70
Viscount Gage 77, 78
The Garrick Club 57, 109, 110
Herbert Art Gallery and Museum, Coventry District Council 45
India Office Library and Records 98, 102, 103, 113
Kunsthistorisches Museum, Vienna 80, 81, 86
Lord Lambton 10–12, 15
The Marquis de Lastic, Paris 65
The Executors of the late Miss O. K. Ll. Lloyd-Baker 87
Mainfränkisches Museum, Würzburg 2, 5
City of Manchester Art Galleries 4
Mr and Mrs Paul Mellon, Upperville, Virginia 42
Mittelrhein Museum, Coblenz 3
National Gallery, London 28
National Gallery of Victoria, Melbourne, Australia 54
National Maritime Museum, Greenwich 111
National Portrait Gallery, London 14, 29, 48, 61, 64, 92, 134
The National Trust (Ickworth, Suffolk) 53
The National Trust (Egremont Collection, Petworth) 43
Sir Arundell Neave, Bt 8
The Hon Robin Neville 7
Galleria di Parma 85
Private collections 20, 21, 23, 34, 50, 51, 59, 60, 83, 93, 104, 108, 135
Museum der Stadt Regensburg 1
Miss Claudine Beachcroft Roberts 96
Dr E. Forbes Roberts 136, 138
The Royal Bank of Scotland Ltd 36
Royal College of Physicians 75
The Viscount Sandon 19

The Trustees of the Tate Gallery 26, 32, 47, 73, 84
Towneley Hall Art Gallery and Museums, Burnley Borough Council 95
Victoria and Albert Museum 16, 17, 30, 89, 90, 94, 112, 137
Victoria Memorial Hall, Calcutta 99, 105
Walker Art Gallery, Liverpool 41
Commander Michael Watson 27
The Hon Mrs Whitfeld 46
20th Baron Willoughby de Broke 35
Sir John and Lady Witt 130
Witt Collection, Courtauld Institute of Art 129
Wolverhampton Art Gallery 18
Yale Center for British Art and British Studies, Paul Mellon Collection 127
Sir William Young, Bt 39, 40
The Marquess of Zetland 56